TELEPHOTO LENS
Photography

ROB SHEPPARD

AMHERST MEDIA, INC. ■ BUFFALO, NEW YORK

Published by:
Amherst Media Inc.
P.O. Box 586
Buffalo, NY 14226
Fax: 716-874-4508

Publisher: Craig Alesse
Editor/Designer: Richard Lynch
Associate Editor: Frances J. Hagen
Photos by: Rob Sheppard

ISBN: 0-936262-53-2
Library of Congress Catalog Card Number: 97-070414

Printed in the United States of America
10 9 8 7 6 5 4 3 2 1

TABLE OF CONTENTS

INTRODUCTION

"Telephotos are magical."

Sooner or later, as photographers get more serious about taking pictures, they want a telephoto lens. Telephotos make photographing certain subjects easier, from wildlife and portraits, to the special world of telephoto close-ups.

Telephotos are magical. They magnify the world and bring in distant subjects, letting us focus on things otherwise hard to see clearly with the naked eye. A telephoto opens ups a whole new way of seeing when added to a camera.

Even in compact, all-automatic, point-and-shoot cameras, the trend is toward making the telephoto end of their zooms longer and more "telephoto". All that you learn in this book about choosing and using telephotos will help you make better photos with any telephoto lens. The captions for the photographs in this book include the focal length of the lens used to take the picture. This will help to show you what the different telephoto lengths can do.

This book also will help you control your images and make them more dynamic and interesting. You'll make images with more impact, photographs that are more likely to make your friends and relatives stop and take notice, and you'll find your photos will be more marketable, too.

All the methods in this book have been field tested and they work. That doesn't mean everything is going to work for you. Good photography is highly subjective and very personal. You have to find out what works for you. Try the ideas here with that in mind. Use and modify them for the way you like to shoot and for the subjects you prefer. If something doesn't make sense to you or doesn't work, go on to something else.

The absolute, number one way to become a better photographer and to master any technique is to take pictures — just get out and use your camera. And have fun!

Rob Sheppard *is the editor of* Outdoor Photography *and* PCPhoto *magazines. He has worked as a naturalist, a photojournalist, a commercial photographer and video producer and has been the associate editor of* Petersen's Photographic *magazine. His photographs have appeared in everything from annual reports of Fortune 500 companies to national magazines and calendars.*

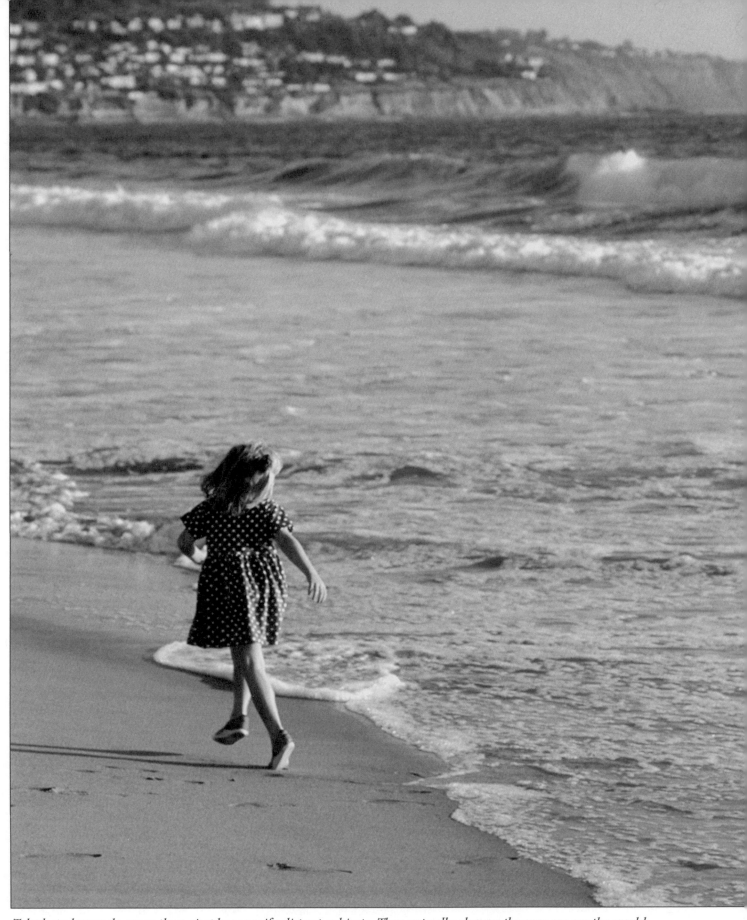

Telephoto lenses do more than simply magnify distant subjects. They actually change the way we see the world, including modifying perspective, affecting depth perception and altering colors. 200mm.

Chapter 1

TELEPHOTO ADVANTAGES

TELEPHOTO ADVANTAGES:

- Change angle of view
- Emphasize details
- Alter depth of field
- Affect shutter speeds
- Modify perspective
- Transform the look of the atmosphere
- Influence perceptions of color

A telephoto magnifies distant objects and brings them closer. This is the number one reason people first buy a telephoto or use the telephoto end of a zoom. Telephotos do much, much more than that. They will:

- Change the angle of view on your scene (bring it in closer)
- Emphasize details
- Alter depth of field
- Affect usable shutter speeds
- Modify perspective
- Transform the look of the atmosphere including haze and fog
- Influence the viewer's perceptions of color

A longer focal length lens brings in details you can't get close to, isolating them out of a larger view, emphasizing what's important. 105mm.

The Pentax SMCP-FA 300mm f/2.8 ED(IF) lens.*

The Lie of Capturing Reality

To really understand how a telephoto can help you, you must understand that the saying "the camera never lies" is a myth. A camera almost always "lies"

in that it cannot capture reality the way we see it. You can easily prove this to yourself by looking at the latest photos by your neighbors who went to the Grand Canyon. If photography were a great way of capturing reality, their photos would automatically make you "ooh" and "aah" at the magnificent scenery. Too often they don't.

You may also know (and envy) a wealthy friend or relative who has all the latest and priciest cameras and accessories, but isn't a serious photographer. Their photos are about as exciting as watching snails climb the bougainvillea and no closer to "reality" than anybody else's.

The problem is that photographs don't see reality, we do. The photograph offers a two-dimensional interpretation of a three-dimensional world, a limited palette of color compared to nature, no context of the scene, no sounds or smells, no wind, no heat or cold, and a photo doesn't move. Just the act of framing a scene — selecting an image out of the infinite number of possible compositions — changes the representation of reality. If you photograph a baseball player at a ball game, you might have a choice to include the empty or full seats in the background. Ask yourself which view is more "real"?

A telephoto can magnify and isolate a bird on a tree so that it looks like it is in beautiful natural setting, even though the bird could be in front of the ugliest suburban office buildings ever built. The telephoto allows the photographer to keep that bit of reality out of the photo.

Practice

To understand how a telephoto affects the world, you need to start seeing the world as a telephoto would. With practice, you'll be able to actually visualize what a telephoto will do to a scene before you even look through the viewfinder.

Looking through your camera and lens a lot is the biggest help. Bring the camera up, see what the scene looks like, change focal length, and try again. Do this in a variety of situations, even if you do not like the subject as a photograph. It will show you how the telephoto affects scenes.

You can also try a technique used by all those directors you see portrayed on the big screen — use your hands. Hold them up in front of you, palms out, thumbs touching. You have now created a viewing area, open at the top, but bounded at the bottom with your thumbs and at the sides with your pointing fingers. When your hands are close to your face, it is like looking through a wide-angle lens. Push your hands to arm length away and you get a telephoto view. If you compare this to looking through your lens, you can actually figure out approximate focal lengths for the distance from your eyes to your hand "frame". You can also take a piece of cardboard and cut a "window" in the center as a frame. The cardboard blocks out more of the surroundings, just like a camera really does.

These simple techniques can also help you decide what focal length lens to buy next. What framing do you consistently try to see with your hands or cardboard that you can't do with your present equipment?

Angle of View

A telephoto sees the world in a narrow angle of view compared to our normal vision. It then magnifies that smaller portion of a scene so it fills the picture area.

> "Telephotos can magnify and isolate..."

ANGLE OF VIEW

The angle that a lens sees using the lens as the apex or point of the angle.

This is extremely helpful for wildlife and sports photography. Many times the photographer simply cannot get close enough to the subject to fill the viewfinder (and resulting photo) with an interesting image. The telephoto "reaches out" by narrowing the field of view to a more manageable area around the subject, and suddenly that white-tailed deer or baseball action is right in front of you.

It also helps when you're stuck in a position and can't move. For example, the telephoto will let you capture a close-up of the Abe Lincoln face on Mt. Rushmore or you can feature a beautiful tree in full fall color on the other side of the river.

Emphasizing Details

Because a telephoto reduces the area of view for the camera and isolates the subject, it really encourages the photographer to look at the details of the world. Now you have the opportunity to show your viewer things they might have passed over in the jumble of a real scene, simply by magnifying it and bringing it close.

Telephotos don't do as well at showing overall views. Even when you're far away from something, like a mountain range in Utah, you're still looking at details of a big view when using the telephoto. Such lenses discourage the broad, sky-filling point of view that wide-angles find so easily. Wide-angle lenses excel at showing everyone the scope and broadness of the world, while telephotos work to enhance the detail by isolation.

"...the opportunity to show your viewer things they might have passed over..."

The narrow angle of view of a telephoto allows you to emphasize telling details of a scene, extracting what is important to the photograph and eliminating what isn't. 135mm.

Changing Depth of Field

Depth of field is very important in controlling which parts of your image are sharp or unsharp. You can control what your background and foreground look

like. With the right choices, the background and foreground grow fuzzier and less distinct.

Other choices make these picture elements tighten up until they are possibly as sharp as your subject and highly recognizable.

Depth of field is affected by three things:

- Distance to the subject
- F-stop used
- Focal length

Although this is a book based on focal length, you need to understand that distance and f-stop do control the depth of field allowed by any lens.

Distance

The closer you are to the subject, the less depth of field you get. The farther away from a subject you are, the more depth of field. So, you do not need a small f-stop for depth of field on a distant subject.

F-stop or aperture

The larger the f-stop (smaller the number), the less the depth of field. The smaller the f-stop (the larger the number), the more the depth of field.

(A note: For photographers who don't know f/stops, this may seem a little confusing. Just remember that the smaller the f-stop number, the smaller the depth of field; the larger the f-stop number, the larger the depth of field.)

Focal length

The longer the focal length (i.e., the higher the millimeter or mm designation of the lens), the less the depth of field you'll get. This gives photographers a wonderful creative tool. You may actually decide to use a certain focal length for its depth of field characteristics, even though that focal length might not be normally used for that subject.

One excellent way of making a subject stand out from its surroundings is to make it sharper than everything else. The telephoto does this so well, it almost becomes an automatic effect. You can actually select a specific area to be in focus with every other area, front and back, out of focus for a very dramatic, "selective-focus" technique.

Use a larger f-stop, get closer to the subject with your telephoto, and the background will become so out of focus that colors and shapes start to blend. This can make a very appealing, non-distracting background for your subject. But be aware that depth of field can become so narrow that only part of the subject is sharp, too. Choose carefully what has to be sharp in the image.

Suppose you are photographing a golfer at the tee and want to isolate him or her so you can see the form of the swing. Put on a telephoto lens, chose a larger aperture, and back up until you can see the whole golfer. The background will be less sharp, making the golfer stand out against it.

Telephotos are more difficult to use when you try for more depth of field — it isn't in their nature. However, you can get as much as is possible by using the smallest apertures and avoiding close shots and very long lenses.

Effect on Shutter Speed

Telephotos demand either fast shutter speeds or tripods. Not only does a telephoto magnify distant objects, it also magnifies any movement the camera

DEPTH OF FIELD IS AFFECTED BY:

- **Distance to the subject**
- **F-stop used**
- **Focal length**

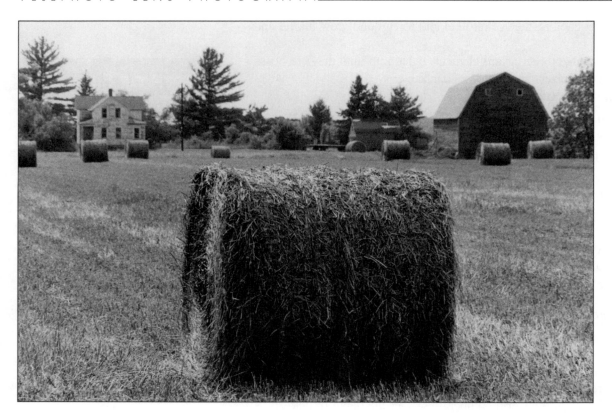

The bale of hay in the foreground of both of these photos is the same. The distance to the farmhouse and barn in the background appears to change because the focal length of the lens and the distance of the camera to the bale has changed. The long lens (top, 300mm) compresses distance, giving a different perspective and reality than the shorter lens (bottom, 50mm).

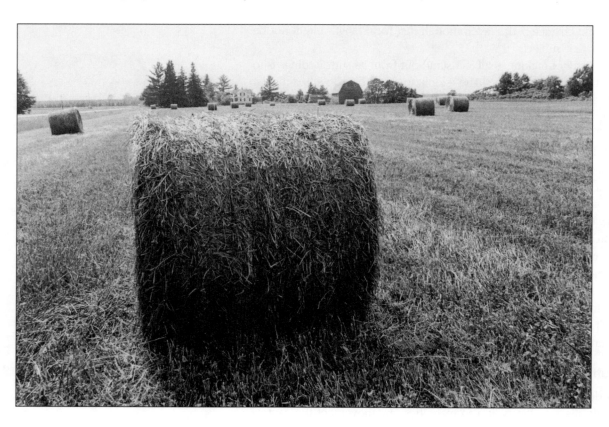

might make while the shutter is open. Camera movement is one of the most common reasons for unsharp pictures. Photographers new to telephotos sometimes are disappointed in their sharpness because of this.

The lens often can deliver more sharpness than the photographer is getting, just because camera movement limits it. An old rule of photography that really works for most people is: the reciprocal of the focal length of a lens is the slowest shutter speed that can be sharply handheld.

The longer the lens, the faster the shutter speed needed (this does vary from individual to individual). This is why people sometimes have trouble with zooms — the wider focal lengths seem to be sharper than the longer focal lengths of the same lens. Often, the lens is sharp throughout its range, but too slow a shutter speed is used for the longer focal length. Some sample focal lengths and the slowest handheld shutter speed (never a slower speed than the reciprocal) are:

70mm of a 70-210mm zoom	1/90 for 1/70mm
210mm of a 70-210mm zoom *(note the difference for this one lens)*	1/250 for 1/210mm
105mm	1/125 for 1/105mm
200mm	1/250 for 1/200mm
300mm	1/350 for 1/300mm
400mm	1/500 for 1/400mm
500mm	1/500 for 1/500mm

This also emphasizes the sensitivity of bigger telephotos (300mm and above) to movement when the shutter goes off. Even when on a tripod, a big lens can be moved by the wind or even your hand, making shutter speed still important. Such a lens requires a heavy tripod.

Perspective

One of the best creative controls of a telephoto lens is its ability to affect the perspective of a photo. Perspective has nothing to do with depth of field. It is the way objects change in size as they change distance from the observer — you the photographer.

Some people will tell you that it isn't the lens, but the distance to the subject that controls perspective. That is technically true — however, for the same subject and environment around it, you have to change distance when you change focal lengths or you won't have the same framing. Distance and focal length are irrevocably connected as far as perspective is concerned.

The affect on perspective is simple — the longer the lens (the more powerful the telephoto), the more perspective is flattened and the background starts sneaking up on the foreground. Place two basketballs five feet apart. At 80mm, they look a certain distance from each other (you might even guess five feet) and the back ball is distinctly smaller than the front. When seen through a 500mm lens (keeping both in the same relative composition), the back ball looks like it's practically touching the front ball and they both look about the same size.

This is the effect all those photographers use to make freeways look more clogged than they really are. A 500mm lens will make the cars look like they are in a densely packed parking lot, when an 80mm lens would actually give them space to drive.

PERSPECTIVE

How picture elements change in size with distance. Close objects look bigger than distant objects, but the exact size relationship can be changed by changing focal lengths.

Now when a news photographer tells you his or her work is totally objective, ask them when they last changed lenses while photographing a crowd. Did they make that rally look weak and sparsely attended (normal or wide-angle lens) or did they make it look like a densely packed, hugely successful event (the long telephoto)? This is a great creative choice when you're simply trying to interpret your view of the world, but may become a bit of a lie when it is used to "interpret" the news.

Use this tool to control the size of your background, too. Suppose your background is a jumble of bright and dark areas. Put on a telephoto lens (or zoom to a longer telephoto setting on your zoom), keep your subject the same size, and you might enlarge a dark shadow behind it so the shadow now fills the whole viewfinder. A dramatic picture appears from what looked like a distracting composition.

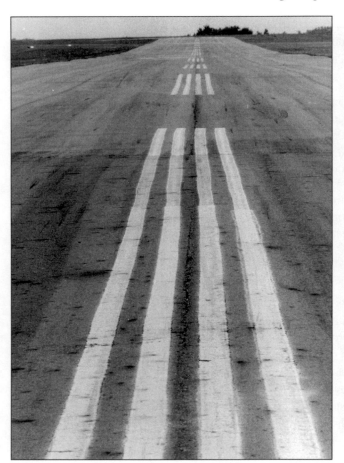 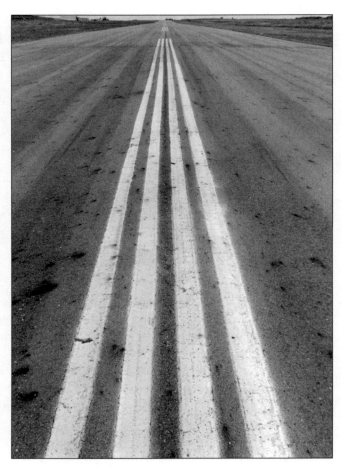

These two shots are of the same runway, the same strips. The perspective and feeling of distance has changed dramatically because different focal lengths were used. The actual distance to the background seems to be considerably different, yet the physical distance from camera to runway end is the same. Extreme focal lengths show the strongest effects, such as here. The left photo is taken with a 300mm lens. The right one is shot with a 24mm wide-angle lens.

Aerial Perspective, Haze and Fog

Aerial perspective refers to the way things sort of disappear into the distance. Everything starts to get gray, a little blue and loses definition as you get farther away. This is a normal way people perceive distance.

However, the wide-angle lens obscures this. Distant objects get smaller and you can't see the aerial perspective as well.

Telephotos enhance and emphasize aerial perspective, as well as haze, fog and smog. This can be a boon or a bane, depending on your purpose, but if you know it will happen, you can plan to use it to best effect.

This change of aerial perspective is due to two factors:

1. Telephotos bring distant objects closer, therefore they magnify far-away picture elements that are beginning to show the graying, the blue-coloring and loss of definition of aerial perspective.

2. Telephotos have to shoot through more air to get to the subject, and they compress the air, so anything in the atmosphere, such as haze, fog or smog, will be intensified. This can be a lovely effect when you want it. It can also force you to do close ups if the air is really ugly.

Colors

All of the telephoto effects you now know combine to affect colors, not changing them, but definitely affecting any colors within the composition.

A telephoto tends to make colors larger, softer and less well-defined as compared to wider-angled lenses (this effect is true whether you compare a 200mm lens to an 80mm or an 80mm to a 28mm, the relationship is what is important). It does this in several ways:

1. *Angle of view* — a narrower angle of view limits the colors of a scene because your viewfinder is now filled with a smaller area of the world.

2. *Details* — usually individual details hold fewer colors than the overall scene.

3. *Depth of field* — since a telephoto reduces depth of field, it often makes background colors less sharp or even out of focus, giving a soft, impressionistic look.

4. *Perspective* — when a telephoto makes the background bigger in relation to the subject, the area of color gets bigger, too.

5. *Aerial perspective, haze and fog* — emphasized by a telephoto, all reduce the brightness and saturation of a color.

Realize that these factors are not negative or positive — it all depends on what you want to do. For example, a shot of blooming cherry trees might be greatly enhanced by a very long telephoto lens because the colors would mute and blend, giving an airy springtime feel to the image. If you wanted to see all the flower colors in sharp contrast to the blue sky, you might need a shorter telephoto or even a wide-angle lens.

So What Do Telephotos Really Do?

They offer the photographer a tremendous tool to control the image in ways beyond simply changing the angle of view to bring subjects in close.

> **COLOR IS AFFECTED BY:**
> - Angle of view
> - Details
> - Depth of field
> - Perspective
> - Aerial perspective, haze and fog

"...a tremendous tool to control the image..."

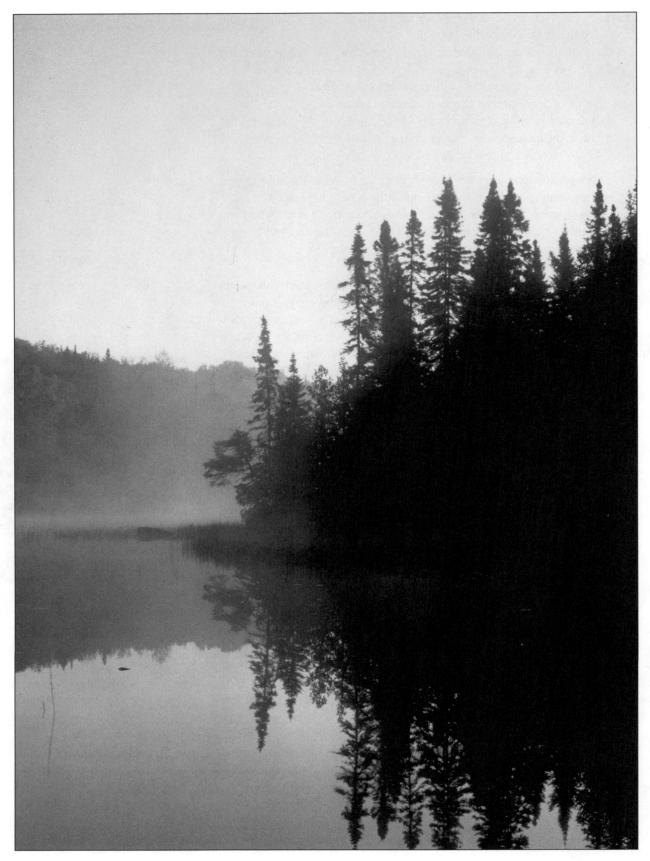

A telephoto lens emphasizes the early morning mist on a lake by reaching out and isolating the fog. This mist would look rather weak with a wider angle lens. 200mm.

Chapter 2

How to Choose a Telephoto

By now you've got a good idea of how you might use a telephoto lens. As you consider buying these lenses, you need to think how to get the best telephoto for your purpose and budget.

You might check out the latest photo magazines, or you could read through all the lens manufacturers' literature. This will certainly give you some ideas to try, but it might not bring you to the best decision on a lens.

The Test

One of the best ways to know what new focal length you really need is to see where you get frustrated with your present work. Your portraits aren't what you'd like? Try a moderate focal length like 80-100mm. You can't get close enough to wildlife? You won't be satisfied with anything less than 300mm and that might not be long enough if your subjects are very skittish or very small. Your kids are either too close or too far away when you're shooting their soccer game from the sidelines? A 75-300mm zoom might be just right because you can use the wider focal length for when they are close, then zoom to 300mm when they're at the other end of the field.

Don't buy a lens because somebody says you need a telephoto. Buy it to fill a specific need in your photography.

Zooms vs. Single-focal Lengths

Not that long ago, any photographer who wanted a really sharp lens stayed away from zooms. That's not true today. Remarkable advances in lens design and manufacturing technology have allowed zooms to be made that easily rival the sharpness of single-focal-length lenses. There are advantages and disadvantages to both types of lenses.

Advantages of telephoto zooms:

- One lens covers many focal lengths, so you buy fewer lenses.
- You can change framing (size) of a subject without changing position.
- A versatile combination of focal lengths can be found in a convenient package of a few lenses.
- You can quickly see the effects of different focal lengths without having to change lenses.
- Manufacturers are emphasizing zoom production in the moderate telephoto range so you have a lot of choices at great prices.

"...get the best telephoto for your purpose and budget."

Canon Zoom Lens EF70-200mm 1:2.8L (Ultrasonic).

Minolta Maxxum AF 85mm F/1.4 Lens.

Advantages of single-focal-length telephoto lenses:

- Usually faster than a zoom. Many zooms are very slow (with smallish maximum apertures) and require more light, faster film or tripods when the fast single-focal-length lens doesn't.
- Usually smaller than a zoom of equivalent size and f-stop.
- Easier to find in longer focal lengths.
- More lenses are available with special glass that minimizes optical aberrations of longer telephotos.

The decision comes down to what do you really need. For bird photography, you'll probably be better off getting the best 400mm lens you can get. But if you do a lot of landscape photography and like to see the effect of different focal lengths, an 80-200mm zoom will likely better fit your needs than a single-focal-length lens.

Focus — AF, Manual, On-demand Manual with AF

Autofocus (AF) now dominates the 35mm single-lens-reflex market. Although many photographers were leery of it when it first came out, today's AF systems are superb. They focus quickly and sharply, and are a benefit to most types of photography.

Telephotos change this a bit. Autofocus does work great with telephotos, but because of the shallow depth of field and narrow angle of view telephotos offer, autofocus sometimes focuses on the wrong things or searches too hard for focus. You need to be able to change the autofocus easily on a telephoto. Sooner or later you will want to shoot with manual focus.

Most lens focusing mechanisms will be damaged if you try to focus with AF on. Many lenses have an on/off switch for AF on the lens barrel itself — be sure you know where it is so you can turn it on or off as the need arises without taking your eye from the viewfinder. Some lenses can only have the AF turned on or off at the camera. These are not as easy to use.

Lens designers have started to add special clutches to their AF mechanisms to allow manual focusing without turning the AF off. These are a great help because you can tweak that little adjustment to focus without losing the benefits of AF or stripping any gears.

Telephoto lenses also often feature a limiting switch for the AF to keep the AF from searching over distances not appropriate to the subject. This is an excellent feature. It is very annoying to focus on a bird, have it move, then have the AF go all the way out to infinity or all the way into the closest focusing distance. The bird is lost before focus can be regained. Under some conditions, you may find it necessary to turn the AF off and focus manually.

Lens Elements

All telephoto lenses are made up of many lenses in specially-designed groups. It is possible to focus a single lens, like a magnifying glass, and get an image. However, it would not be a sharp, clear image, corner-to-corner, edge-to-edge as we expect from a camera lens.

All sorts of problems (lens aberrations) would crop up, and we'd have to deal with a lens that was physically as long as its focal length. A 500mm lens would therefore be 500mm long — that's a lens nearly 20 inches in length! So lens designers long ago learned that when they combined single lens elements into groups, they could correct these problems and make long-focal-length

LENS ABERRATIONS

Defects in the performance of a lens due to optical problems.

lenses smaller (that's actually what a telephoto lens is — an optically-shortened long-focal-length lens) as well as making them sharper with more contrast and brilliance.

Lens aberrations come in two basic types: chromatic aberrations (where colors do not focus at the same point) and monochromatic aberrations (where light behaves differently through the center of the lens compared to the edges — this includes spherical and comatic aberration).

Lens elements are combined in a lens based on their curvature, type of optical glass and the amount of air space between them. All of these reduce and sometimes even eliminate lens aberrations to achieve top performance from a telephoto lens.

Telephoto lenses tend to have the most problem with chromatic aberration, especially as the focal length increases. All photographic lenses are designed to align at least two wavelengths (typically red and blue) so they focus at one point. For wide-angle and normal-to-moderate focal length lenses, this is usually enough, since the intermediate color (green) will follow closely to the red and blue.

Longer lenses have trouble doing this, especially lenses over 300mm with lots of glass, i.e., "fast" lenses with large maximum f/stops. In response, designers have added special glass, called low-dispersion, ultra-low dispersion, super-low dispersion, extra-low dispersion (and so on — you get the idea), that allow them to minimize the problem. Now all three main wavelengths of light (red, blue and green) can be focused to one point. This is called an apochromatic lens (often abbreviated as APO).

Low-dispersion glass allows some other benefits as well: the lens will gain sharpness right up to the edges of the frame; contrast and brilliance of the image will increase; and the lens can be shortened significantly.

Shorter focal lengths benefit less from low-dispersion glass, so it is rarely used in them. They have less of an inherent problem with chromatic aberration, but more of a problem with spherical aberration. This is especially true with wide-angle to telephoto zooms. Modern lens design corrects this nicely, but there are limitations on lens size (lenses get bigger with added correction) and f/stops (maximum f/stops are restricted, particularly with zooms).

Advances in lens design and lens processing technologies have allowed the use of aspherical lens elements to reduce these problems in shorter focal lengths. Aspherical lens technology has actually been around a long time — manufacturers just couldn't control its production in the past.

An aspheric lens actually has a lens surface that changes its curve from edge to center. It can significantly reduce spherical aberration common to a spherical lens (a lens with one curve from edge to center). They are now being used to compensate for these aberrations often found in large-aperture lenses and to make highly compact, very high quality moderate-focal-length zoom lenses.

Maximum Apertures

Telephotos almost always have smaller maximum lens openings than the "standard" focal lengths around 50mm. As the lens size increases, it becomes more difficult to increase the diameter of the lens enough to allow large apertures (therefore making a faster lens).

Also, lens aberrations tend to multiply. Even more glass is needed to correct the aberrations, along with specialized manufacturing techniques.

TWO TYPES OF LENS ABERRATIONS:
- **Chromatic**
- **Monochromatic**

Sigma APO 135-400mm Zoom lens.

ASPHERIC LENS

A special lens element having a free-curving surface (not spherical) that corrects spherical aberration in a lens (mostly a problem with very large aperture and wide-angle lenses).

So a faster lens will usually be heavier and will always be more expensive. Adding just one more f-stop of speed to a long telephoto can make the lens double and even triple in price. This does not mean the more expensive lens is a better lens. Sometimes the slower one (the cheaper one) will be better because lens aberrations are more easily controlled when the maximum lens aperture is smaller.

If you need the lens speed for wildlife or sports action photography, the faster lens may be a necessity. If you don't need the speed, you won't gain anything from the higher-priced lens except a heavier load and a lighter wallet.

Internal Focus

Internal focus used to be found only on very expensive telephoto lenses. Today, lens manufacturers are designing it into more and more lenses. This feature can be very helpful.

When a lens focuses normally (without internal focus), the focusing mechanism moves the lens elements physically forward and backward until the image is sharp. The result is that the lens actually changes length — it's at its shortest length when focused at infinity, its longest when focused up close. This is no problem with a small lens, but on a big telephoto, it changes the balance of the lens. This can make it harder to support for sharp pictures.

With internal focusing, the lens designers figured out a way to focus by moving a group of lens elements inside the lens without changing the length of the lens. The balance of the lens was improved immediately. Internal focusing also allowed designers to place the focusing ring near the center of balance of the lens rather than out toward the end, improving handling even more.

To move the large front elements of a telephoto is a lot more work than moving the smaller elements of the middle or back of a lens. Internal focus therefore allows the lens to focus faster, whether you do it manually or with AF. This can be a key benefit with any sort of moving subject as in wildlife or sports action photography.

Finally, internal focus allows designers to make lenses that focus closer and with correction for optimum sharpness.

Internal Baffling

Once light gets inside a lens, it starts to bounce around, besides heading for the film plane. All that glass not only focuses the subject, it also reflects light to a degree (this is especially a challenge with zoom lenses because they have so many lens elements).

Modern multicoatings on the lens surfaces minimize light bounce and flare, but still, more light is inside a lens than actually ends up on the film. This light bounces off the inside of the lens mount, off the edges of lens groups and much more and results in a lower contrast lens that gives less brilliance to an image.

The best lenses have deep black, totally non-reflective interiors. You can't even see the edges of the lenses (you will see light edges on some less expensive telephotos). Look into one of these lenses when the back lens cap is on and you'll just see black.

In addition, lens designers add ridges and baffles inside the lens to cut down on internal reflections. This does add to the cost of the manufacture of a lens and is why more expensive lenses often show better contrast and brilliance.

INTERNAL FOCUS

Groups of lens elements inside the lens move to focus, rather than moving the whole lens away from the film plane (common to older lenses). This internal focusing keeps the lens shorter, maintains the balance of the camera and allows closer focusing.

INTERNAL BAFFLING

Special baffles built into the light path reduce the amount of excess light bouncing around inside the lens (this cuts flare).

Quality

Lens quality can be measured in a lot of ways: sharpness, contrast, construction, type of glass, aberrations, etc. The ultimate test of a lens is how well it works for the types of photography you do.

An expensive, low-dispersion glass telephoto might be a necessity for the pro who must shoot sports with a large aperture, but it might be a terrible choice for the amateur who rarely makes prints larger than 4x6. Few people will see any difference in lens quality among modern lenses at this size print or even larger.

In addition, the expensive glass (you'll often hear photographers refer to bigger lenses as "glass" because they have so much glass in them) will be big and bulky and can weigh several times that of the smaller, less expensive telephoto.

Finally, if you really want to explore the world of the telephoto view, you've got to have a lens to do it. A less expensive lens will get you started. Many pros started with whatever they could afford, just to get going, then bought the more expensive lenses when they could more easily afford them.

"...you've got to have a lens to do it."

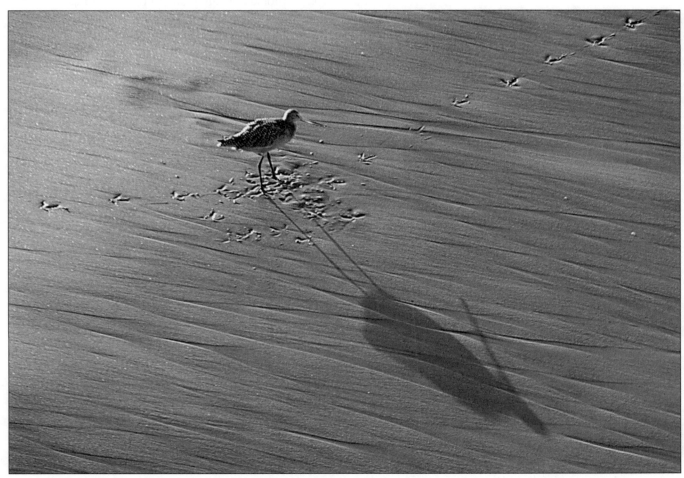

Sometimes people get hung up on the quality of a lens. Modern lenses are generally excellent. The images you capture are more important than the price paid for the lens. Results are what count. 300mm: 100-300mm zoom.

Chapter 3

GETTING THE BEST IMAGE QUALITY

A common reason for rejection of photographs submitted to magazines or photo contests these days is poor sharpness. Modern autoexposure systems have brought good exposures within reach of everybody. Modern autofocus systems mean this sharpness problem is rarely due to poor focusing.

Usually, it's from camera movement during exposure. Remember that telephotos not only magnify the image, but they also magnify even the slightest bit of camera movement. Many photographers only shoot telephoto lenses on a tripod, just for this reason.

Handholding

When handholding a telephoto, you must support it properly. Hold your left hand palm up (it doesn't matter if you're right or left handed), then place the lens barrel into the palm so that it balances without support from your right hand.

Grip the right side of the camera with your right hand, pointer-finger over the shutter release. Lift the camera to your eye, keeping your elbows in to your chest. This is the most stable position to hold the camera.

Never hold a camera by gripping the left and right sides of the camera when a telephoto is attached. That is an unstable position that you must constantly adjust to keep the camera up.

When you release the shutter, gently push the button down. Punching the button causes camera movement.

Be sure to use faster shutter speeds. Just remember that classic rule to always use a shutter speed faster than the reciprocal of the focal length of the lens. This really does work. Although some people claim to get great shots at slower speeds, they rarely can match a tripod-mounted camera, the true test of camera stability.

Tripods and Other Supports

Whenever you can, use added support for your telephoto. That will give you options for exposure that a handheld camera can't (because of shutter-speed restrictions).

Many photographers like shoulder or "gunstock" mounts. These allow you to hold the camera against your shoulder, just like a gun, and are great for gaining a little added support when shooting moving subjects, like wildlife or sports.

Monopods are a great favorite among sports photographers. These are essentially one leg of a tripod with a head (a small ball head works well with

> "When handholding a telephoto, you must support it properly."

MONOPOD

A highly portable form of camera support that is like one leg of a tripod. Very portable and light, it is ideal for wildlife and sports photography.

them, and you do need a head). They are quick to set up, easy to move (away from the charging linebacker), don't take up much space when set up and are very light and compact for travel.

A good tripod is an investment in telephoto sharpness that will last a long time if you take care of it. Photographers sometimes spend thousands of dollars on lenses, then skimp on spending anything for a tripod. A less expensive lens on a solid tripod will consistently beat the sharpness of a more expensive lens on a flimsy tripod.

To check a tripod, set it up to its maximum height, lock the legs, lean on it and twist. A good, solid tripod has the rigidity to resist your weight and movement.

A tripod is not complete without a strong head. Photographers split in their preference for either a pan-and-tilt head or a ball head. Both of them (assuming they are heavy enough to handle your biggest telephoto) will do a great job, but they handle the lens and camera very differently.

"A good tripod is an investment in telephoto sharpness..."

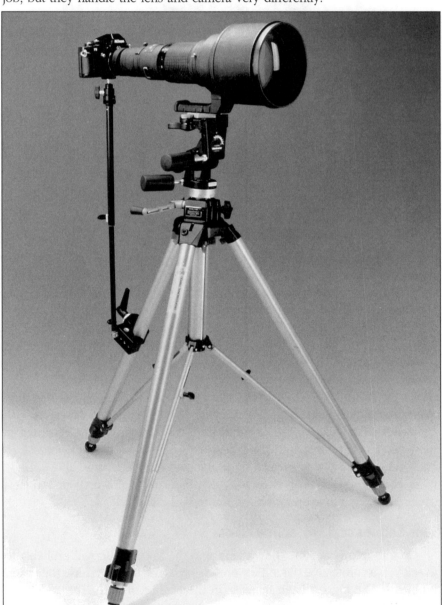

A Bogen tripod and long lens support.

Some people prefer the pan-and-tilt head because they can set the planes of camera movement separately. Other photographers like the ball head because they can control all the planes at once by just loosening and tightening one knob (outdoor photographers on rough terrain like it for that reason). Beware though, the ball head is often nick-named the "dump head" because it will quickly dump a heavy camera/telephoto-lens combination, if you aren't holding the lens securely when you loosen that knob.

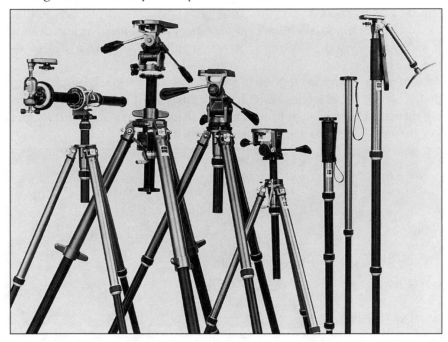

Gitzo tripods and monopods.

Other special mounts are available for telephotos, including car-window mounts, which are great for wildlife photography (turn off the engine when you shoot, however), and bean bags (which will cradle a long lens against many supporting surfaces from a car top to a rock to a fence post).

Use a cable release for slower shutter speeds whenever you use a tripod. The telephoto will magnify your hand's movement on the camera as you release the shutter. Newer cameras have electronic cable releases and even remote release capabilities — both work great.

Finally, just because a telephoto is tripod mounted, don't expect it to automatically produce high sharpness every time. 1/15 is a tough speed for most cameras with telephotos. The way the mirror bounces inside an SLR causes the most camera movement at this speed. Avoid it if you can with telephotos.

Wind is also a big problem with focal lengths of 300mm and above. Under these conditions, you may need to weigh the camera down (your weight, a camera bag, etc.) to keep it from bouncing in the wind.

Lens Shades and Protective Filters

Go into a camera store, buy a lens, and the salesperson will probably try to sell you a "protective" filter. Few professionals use them because they cause problems. The biggest is an increase in the chance of flare. The added surfaces of glass can act as mirrors, reflecting light around in the lens, reducing

LENS FLARE

Bright light bouncing around inside a lens causes flare. Flare degrades the image by reducing contrast (diffuse flare) or by adding spots of "light" to the image (specular flare). It can be reduced by using a lens hood or shade.

the brilliance and contrast of the lens, adding colored spots to the image. Many people seem to feel that since the filter "protects" the lens, they don't have to worry about it. The filter must be kept as clean as a lens. Photographers without such filters often take better care of the front of their lens.

A better protection, and one that is probably the least appreciated, is the lens shade. Telephoto lens shades are big — they keep rain and dirt from the front of the lens and protect the lens' surface from banging into anything. Lens shades also keep extraneous light from getting inside the lens and bouncing around. This can quickly degrade the quality of the image, especially as you shoot toward the sun. Use a lens shade with telephotos whenever possible.

Teleconverters

Teleconverters or extenders have been around for a long time. They multiply the focal length of a lens by 1.5 or 2X (the actual magnification of the 1.5 range varies among different manufacturers), making it a stronger telephoto. Unfortunately, they also magnify lens faults. The real cheap extenders of a few years ago even added their own faults to a lens and could only give poor quality images. Modern, multi-element teleconverters with high-quality modern lenses do have a place in any serious photographer's camera bag. The matched extenders designed for use with specific lenses do an outstanding job of retaining sharpness, brilliance and contrast of a lens.

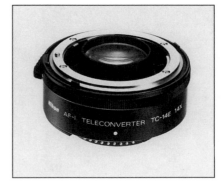

A Nikon TC-14E AF-I Teleconverter (1.4x).

The advantage of a teleconverter is increased telephoto magnification:

- At less than the cost of a new lens.
- In a small, easily carried package.
- At the same minimum focusing distance, giving the lens new close-up capabilities.

The disadvantages of a teleconverter are:

- Drop in light level (you lose one f-stop of lens speed with a 1.5X converter, two stops with a 2X).
- Less sharpness than a single focal length lens.
- Don't always work with autofocus.

Be extra vigilant to prevent camera movement when using a teleconverter. Even a tripod is no guarantee of preserving sharpness. The drop in light often means a drop in shutter speed, and the telephoto/extender combination can make the camera especially front heavy so it wants to drop forward.

Focus

Modern 35mm cameras are nearly all autofocus (AF), but telephotos work just fine with manual focus. They just require some practice if you're going to photograph moving subjects. Excellent, used manual-focus telephotos are available today at very low prices because they are no longer popular. This is a way of increasing your focal-length range when your budget is limited.

Autofocus lenses do have their advantages, though. First, since they are modern designs, they are nearly always smaller than manual-focus telephotos, especially zooms, and older zooms definitely lack the crispness of the newest designs. Of course, you can't autofocus without an autofocus lens. AF systems available now will track even fast-moving subjects, keeping them constantly in focus as the camera shoots away.

TELECONVERTER ADVANTAGES:

- Cost
- Size
- Close-up capabilities

TELECONVERTER DISADVANTAGES:

- Light level
- Less sharpness
- Autofocus doesn't always work

AF also allows very fast focusing on a subject with no movement of your hands. This results in less potential camera movement (and its consequent image unsharpness).

With single-shot AF, you can quickly find a subject, press the shutter release gently, then lock the focus on the subject as you reframe for a better composition. With servo or continuous AF, the camera continually refocuses to track a moving subject and will not lock focus. Most cameras offer predictive AF, a continuous autofocusing that actually uses a little microchip in your camera to compute where a moving subject will be when the shutter actually opens.

Using both manual and autofocus telephotos on moving subjects requires practice. Go out and frame your dog running for a treat or the kids at a local soccer game. Try to keep them in focus. The narrow angle of view and shallow depth of field of the telephoto can make this a demanding challenge.

With manual focus, it's natural to begin focusing on a moving subject before you press the shutter release, but this isn't so obvious with AF. Yet, you need to give the camera a chance to catch up with the subject before the critical composition or action is seen. Get the AF system working by depressing the shutter release, then follow the action, letting the AF do its job as you watch for the best time to shoot.

Bright areas in the image can throw off your meter, making your picture underexposed. Try framing the middle tones, lock exposure, then reframe back to the desire composition. 85mm, with an extension tube.

Exposure

Exposure with a telephoto isn't a whole lot different than with other lenses. Since the telephoto sees such a small area of a scene, you do need to be careful of a few things. Zoom telephotos can get you into trouble because the camera may change exposure as the lens is zoomed from the wider setting to the longer, more narrow setting, even though the subject's light has not changed. An in-camera TTL meter is designed to make what you see in the viewfinder a

middle-gray tone. The meter doesn't know the difference between a white snow drift and a dark bison — it wants to make both of them gray. So, if a wider shot of the bison in the snow includes a lot of snow, the exposure will be less (making it gray) than the closer-in shot of just the bison (the meter wants to give it more exposure to make it gray). Be aware of this, especially with scenes and subjects with extreme light or dark elements — either lock the exposure in on the most important middle-toned part of the scene (or use manual exposure) or you'll have to live with uneven exposures.

This effect can also be used to your advantage. Suppose you have a great landscape scene with a brightly sunlit grove of trees amongst dark, shadowed hills. Most meters will want to make the hills too bright (gray), which will over-expose the trees. You can zoom in to the maximum zoom focal length to take a reading of the trees, lock the exposure or set the camera on manual, then zoom out to the larger scene for the actual photo.

Moving subjects also challenge your meter. Autoexposure systems will often change exposure as, for example, a race horse passes in front of a dark grove of trees, then a bright area of water. Yet, the light on the horse never changes. Again, that narrow angle of view of the telephoto trips us up. The best thing to do here is take a meter reading that you feel gives the best exposure for the light the subject is in, then use the camera on manual.

"This effect can also be used to your advantage."

Proper technique, attention to how you hold and support your camera and lens, is the key to getting the best pictures possible from your lens. 200mm.

Chapter 4

MAGNIFYING WILDLIFE

"Telephotos lenses are a necessity for serious wildlife photography."

Telephoto lenses are a necessity for serious wildlife photography. While you can get close enough to a dog or a cow to use a wide-angle lens, truly wild animals generally won't tolerate such a close approach. Even at zoos and wildlife parks, the animals have a certain comfort zone that you cannot easily enter.

You must photograph at a distance and magnify the animal so that it shows clearly in the frame. You don't want to do like one woman who proudly took her photo of a bittern to a nature center — the only reason a viewer could see the bird was because it was boldly circled in ink.

Because animals move and are lots of fun to see inside a viewfinder, many photographers make the mistake of thinking they will also be easy to see in the photograph. An animal is distinctly seen when moving against a static background, but stopped in a photo, it often blends in. And the "fun" element is definitely a factor — it can be so exciting to see wildlife framed in a viewfinder that the photographer "magnifies" its visibility.

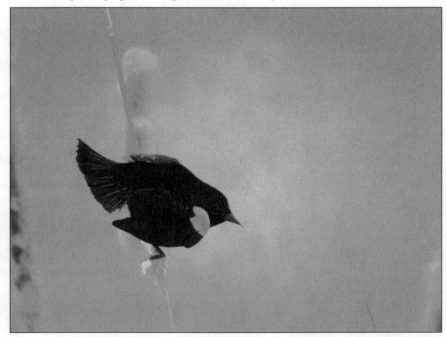

Wildlife won't let you come right up to them. You must shoot them with stronger telephoto lenses to see the color, form and behavior that makes them interesting. 300mm.

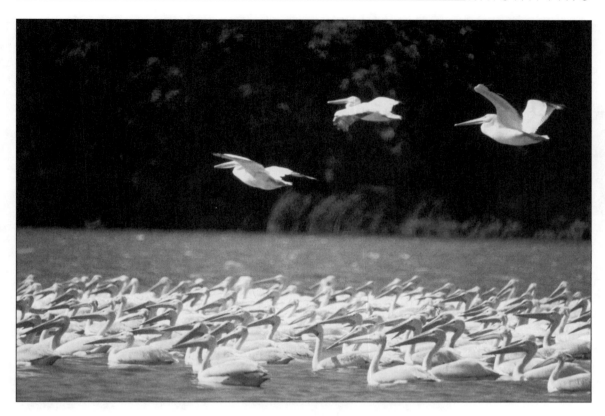

No matter what type of animal you're after, truly wild animals require a careful approach and at least a 300mm lens. A good starter length is 300mm, used on the deer below. Waterfowl often demand longer lenses because it can be very hard to get close to them. They have exceptional eyesight. The pelicans above were shot with a 500mm lens.

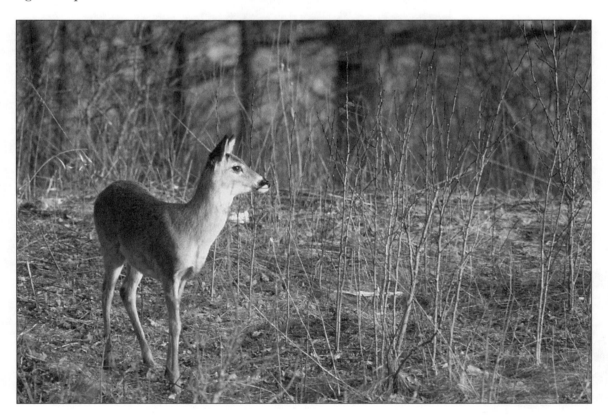

Focal Lengths

Telephotos allow you to reach out and get dramatic images of exciting wildlife subjects. Generally, the smallest useable focal length is 200mm. Here are some focal lengths and uses to consider:

- *200mm* — easily handheld, reasonable magnification for large animals; great for zoos and wildlife parks; too short for most birds.
- *300mm* — probably the best all-around focal length, handholdable; good magnification of large animals, reasonable for larger birds; great for zoos and wildlife parks; a good focal length for use with high-quality teleconverters to give a relatively small, two-focal-length package.
- *400-500mm* — excellent focal length for birds and distant larger animals; usually best with a tripod; these are big lenses that can be heavy and awkward.
- *600mm and above* — a necessity for wary animals, especially some waterfowl, but not for handholding; big lenses that need big tripods and big heads.

Nikkor 600mm Lens.

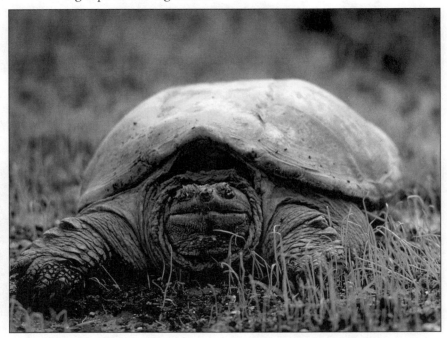

Even though you might be able to get close to this snapping turtle, you might not want to. A 300mm lens brings in a nice, close shot from a comfortable distance.

F-stops

Much wildlife photography is shot at wide-open f-stops, so lenses need to be sharp then. Longer telephotos especially benefit from low-dispersion glass elements to enhance sharpness.

The wider f-stops are needed for two reasons: first, wildlife is often most active early or late in the day, when light levels are lower. Second, the constant battle with camera movement and big lenses is lessened when faster shutter speeds can be used (which require wider lens openings).

WIDER F-STOPS ARE NEEDED FOR TWO REASONS:

- **Lower light levels**
- **Faster shutter speeds**

Large birds and animals protected in parks and refuges will let you get closer than those harassed by hunters, for example, but you'll still find at least 300mm is needed for dramatic images. 300mm.

Many pros shoot all their wildlife images at the widest lens openings. This guarantees the fastest possible shutter speed will be used for proper exposure. It is also an easy way to ensure fast shutter speeds when shooting with auto-exposure — simply use aperture priority and the camera will always choose the fastest speed appropriate to the conditions.

An added benefit comes from the combination of long telephoto and wide lens opening — the shallow depth of field. This tends to make animals stand out better from their surroundings, even when the animals' colors tend to blend in.

With the increasing quality of high-speed color print films, many photographers are finding them a great help in getting better wildlife images. These films offer remarkable color, sharpness and grain structure not possible even a few years ago. They allow you to use smaller f-stops if you want to try for more depth of field, faster shutter speeds under more conditions if you don't, and easier use of light-eating teleconverters.

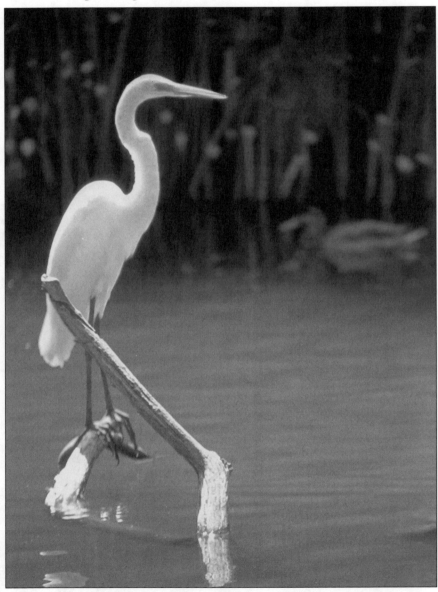

A telephoto zoom brought this egret in close for an interesting composition. 300mm: 100-300mm zoom.

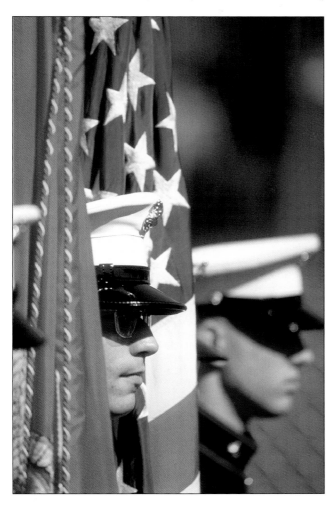

Left: A telephoto lens compresses distance and color for a dramatic, almost abstract shot of a color guard. *300mm.*
Bottom: Sometimes a little detail in a scene can be more telling about people than seeing their faces. The telephoto lets you reach out and find those details. *200mm.*

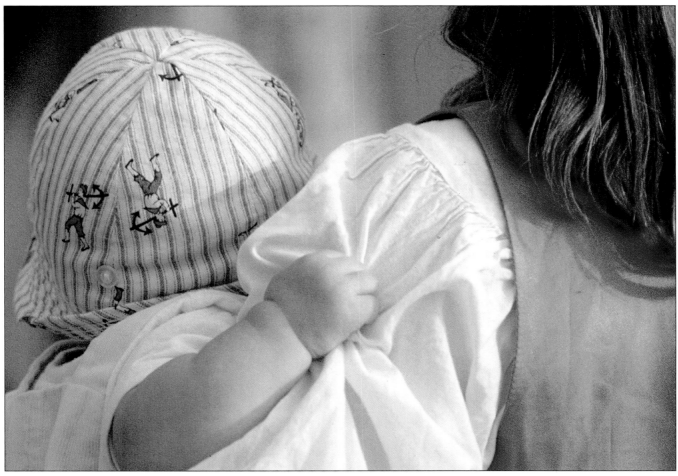

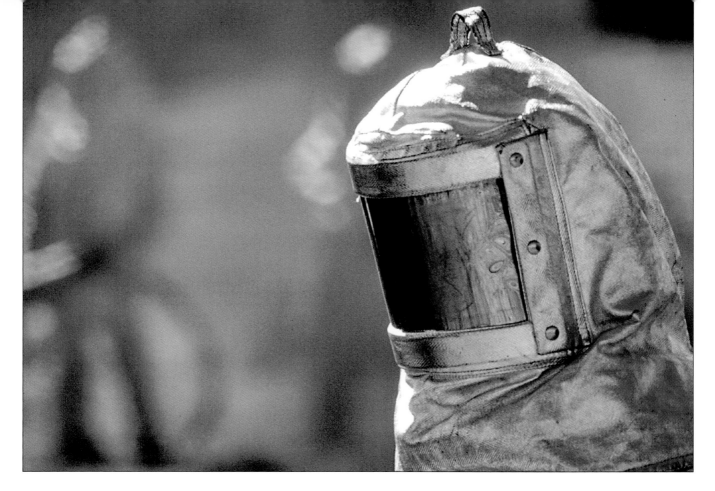

Above: *At times a telephoto is the only way to get an image. This close-up of a firefighter would not have been possible with even a short telephoto lens (the photographer was not allowed closer). 300mm.*

Below: *A long lens can also be used even if it is not required by the subject, just for its interesting effects. Here, it flattens and simplifies the background for a portrait of a boy. 400mm.*

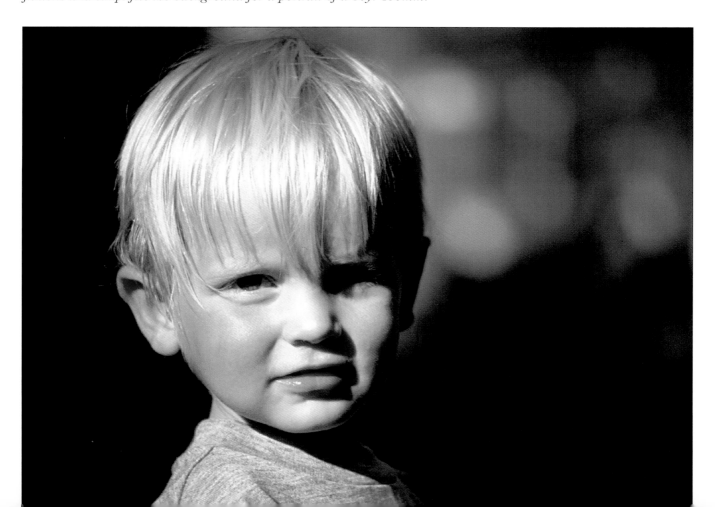

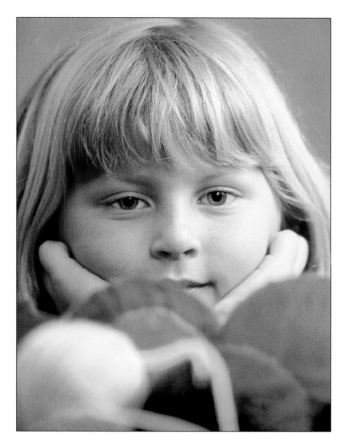

Top, left: *A 300mm lens was used for this portrait to deliberately flatten perspective in the foreground to build an image of color with the girl.*

Top, right: *An 80-200mm zoom is a great travel lens because you get a lot of focal length choices in one package. The 200mm end works great to find and isolate details in a scene.*

Bottom: *Bright sun and shooting wide open allowed a fast shutter speed (1/2000) to capture racing action seen by a 200mm lens.*

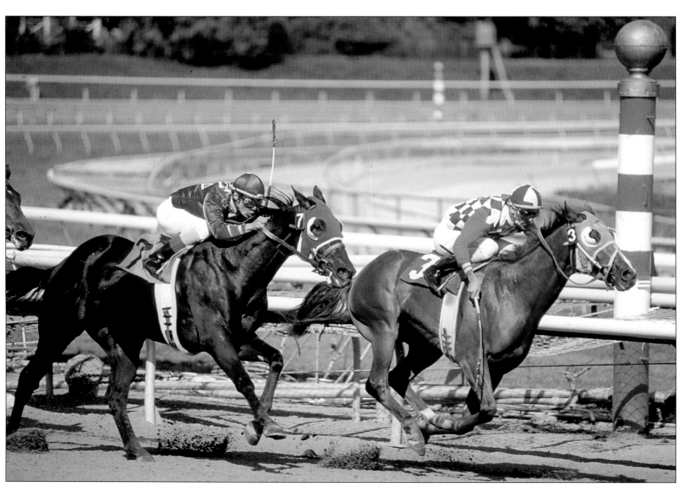

Above: *A moderate telephoto in the 80-100mm range (including zooms that cover these focal lengths) is great for portraits. It keeps the photographer close enough for interaction with the subject, yet far enough away that the subject feels comfortable. 85mm.*

Below: *Kids sports can be a lot of fun to work with, but images often fail because they don't isolate the important moments, gestures and action. A long lens will even bring in the kids in the outfield. 400mm.*

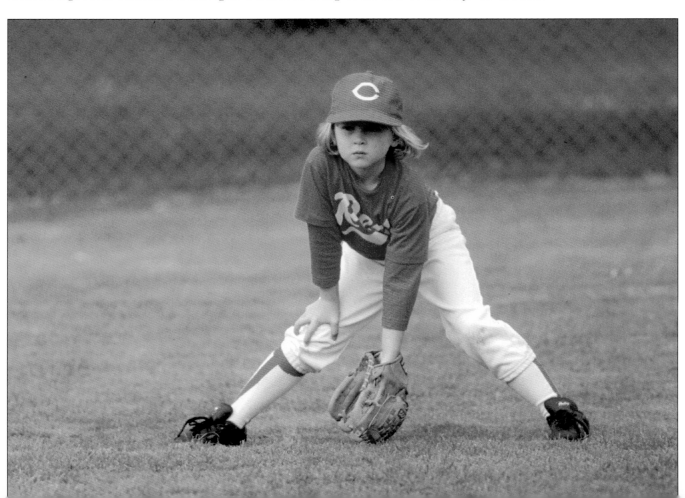

Getting Close

Even with a telephoto, you're still going to have to get close enough to an animal to use it. Pros skilled at this can approach close to even the most wary wildlife. With wildlife, understand that animals all have a comfort zone. If you're outside of it, they stay relaxed and allow your presence. Once you cross its boundary, they get nervous and prepare to flee.

Animals are extremely sensitive to fast movement (that usually means predators to them) and man's silhouette (we're bigger than most animals). Mammals are also sensitive to sound and smell.

No animals like to be stared at (again, that's a predator's behavior), so don't hold your camera on an animal until you are ready to shoot.

To get close to wildlife in the field, keep your movements slow and deliberate, stopping often as you approach (this mimics a feeding animal's behavior). Don't take a direct path to the subject as that is very threatening — approach by zig-zagging at an angle. Bend over a bit to lessen your silhouette — if you can, stay to lower ground and keep a hill, tree or other object behind you that will keep your form from standing out against the sky (animals will notice that).

"...approach by zig-zagging at an angle."

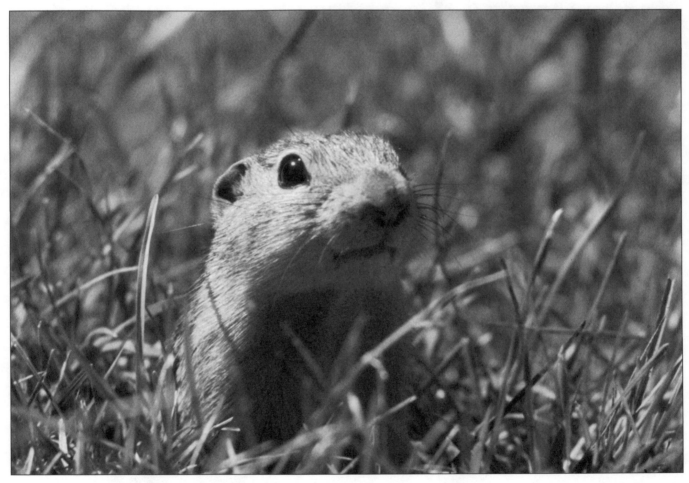

Even common wildlife like a striped ground squirrel (gopher) require a little thought in how you approach them. A low, patient crawl helped to get this shot. 300mm, with extension tubes.

There is an abundance of wildlife in the world to photograph and you don't have to go to Alaska to find it. Be prepared with a long lens and a slow, relaxed approach. 300mm for both.

Birds can see better than most humans, so assume they have already seen you. You have to approach them in such a way that they feel you are no threat. Stay in the open. Birds get very nervous when they see something moving closer suddenly disappear. With mammals, you can use natural cover to get closer, but never do that with bears. A surprised bear can be a very dangerous bear.

Watch the animal. As long as it continues its normal routine or behavior (especially feeding), it is relaxed and will tolerate a closer approach. As soon as it stiffens or straightens up, head held high, freeze. That's an alarm behavior that precedes flight. Also, be careful not to pressure sensitive animals as they get nervous.

You can often get closer to animals by knowing their habits and waiting for them to return to a prime location. You can stake out a spot not far from a deer trail to capture them as they make their way out to feed just before sunset (watch your scent here, be sure it blows away from the trail). Or you can set up a comfortable, shielded seat near a feeding area and wait for the birds to come to feed.

Blinds are a terrific way to get really close to wary animals, though such structures are beyond the scope of this book. Simply stated, a blind is anything that will conceal the photographer's movement and form from animals regularly coming to an area close to the blind. Photographers have made them from PVC pipe and camouflage material, wood and burlap, old refrigerator boxes and old tents. They can also be purchased in ready-made, easily put-up forms.

You still need a telephoto to get the best images from a blind, especially when using permanent blinds often found on wildlife refuges.

More than Target Practice

To sight on an animal and squeeze the shutter isn't enough if you want images that other people will enjoy looking at. You need to look for wildlife photographs, not wildlife record shots.

Beginning wildlife photographers make the common mistake of always putting the subject in the middle of the frame. They use the focusing aids as targeting devices — not a good idea.

It helps if you watch for four things:

1. *Edges* — always be aware of the edges of the viewfinder. Make sure nothing distracting creeps in to take away from your subject.

2. *Background* — remember that an out-of-focus background is not an unseen background. Bright spots, too colorful areas, distracting contrasts can all take the eye away from your subject even if they aren't sharp.

3. *Light* — the light on an animal makes a big difference. Back light can be very effective to help make the animal stand out from the background. It also makes fur and feathers glow along the edge of an animal. Sidelight will add dimension and texture when that's important. And front light, especially low sun front light, can be most attractive in highlighting colors and patterns. The worst light is generally top light from a midday summer sun, but that's a terrible time to look for animals, too.

4. *Gesture/posture* — just like good people photography, the best animal photographs capture an animal at an interesting moment.

BLINDS

A covering of photographer and camera that conceals the shape and movement of the photographer. Commonly a tent-like structure.

FOR BETTER SHOTS:

- **Watch the edges**
- **Watch the background**
- **Light on an animal makes a big difference**
- **Gesture/posture of the animal**

This may be as subtle as a slightly turned head of a deer or a poised beak of a heron, or a dramatic as a goose's take-off or bear fight. Don't be satisfied with just one shot. Take more as the animal's behavior changes.

"...shoot lots of film."

Actually, one of the best ways to increase success with wildlife is to shoot lots of film. Start shooting as soon as you think you are close enough for a reasonable image, then keep shooting as you get closer.

An animal is not like a landscape that doesn't move. They constantly change postures, attitudes, places in the landscape and offer a multitude of photo possibilities. You cannot possibly know if your first shot was the best until your last shot is done. And even then, you might not know for sure until you get the photos back from the processor.

The best shots of wildlife capture them at an interesting moment. Keep shooting until you are absolutely sure you've captured one. 400mm: 80-200mm with a 2x teleconverter.

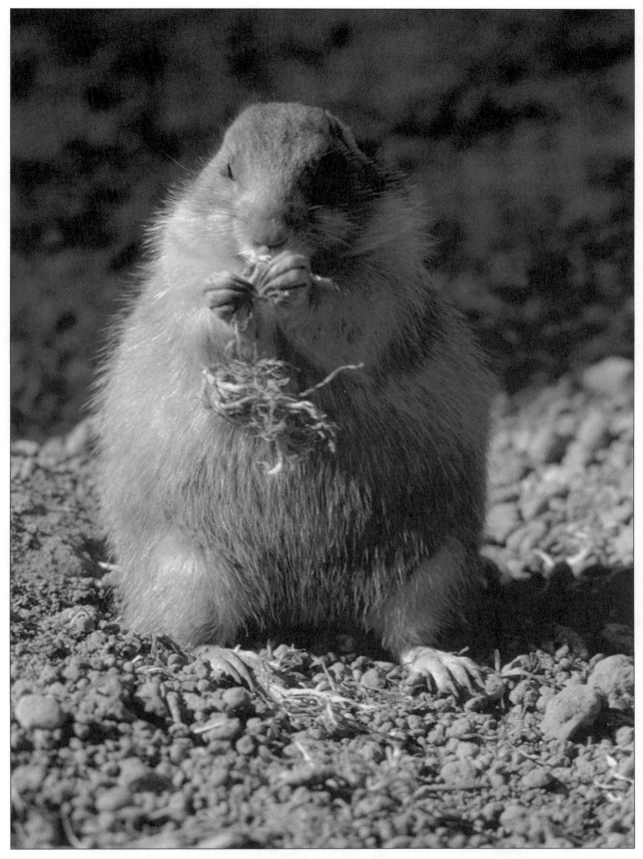

The light on an animal greatly affects both how the animal looks and what the picture looks like. Don't be satisfied with a snapshot — look for the best light on the subject and surroundings. 300mm.

Above: Low front light can be quite effective in bringing out patterns and colors of wildlife. Also, be aware of how the animal relates to the whole image area, not just the center. 300mm plus extension tubes.

Below: While this orangutan is centrally located, every bit of the frame is used. Watch out for too much "head room" above a tightly composed animal. 400mm: 80-200mm zoom with 2x extender.

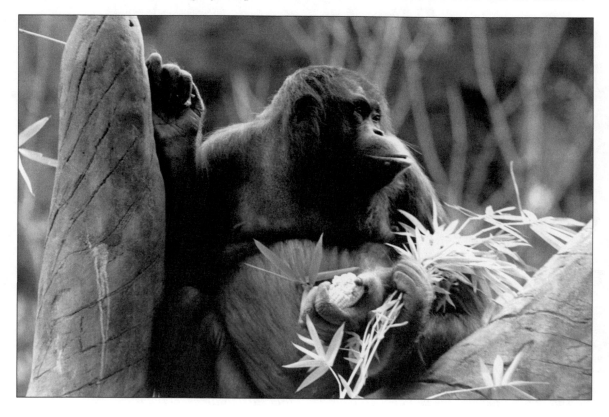

Chapter 5

PORTRAYING PEOPLE

Friends and relatives, spouses and kids, brides and graduates, sooner or later, get captured by the camera. Nearly every magazine uses photos of people, often on the cover, because people photos can strongly affect readers. Few newspapers could exist without people photos, nor could most companies' advertisements and brochures. The telephoto is an important tool for capturing these images, and if you understand how to use its strengths, you'll create some memorable images.

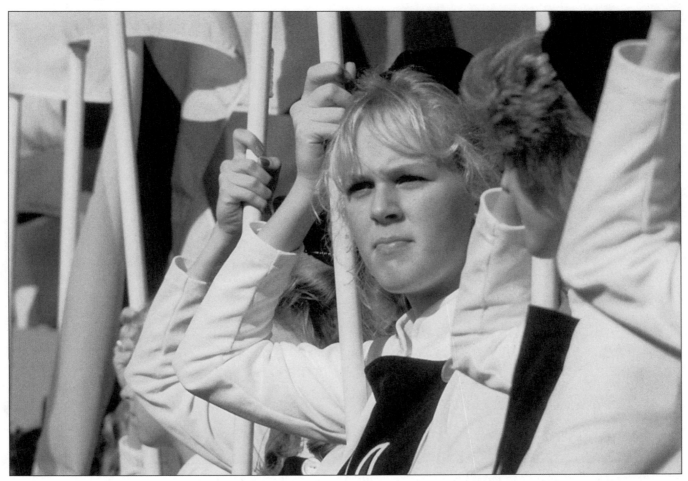

The distance compression and selective focus abilities of a long lens allow the "sharp" girl to stand out from a forest of flags. Catching the right moment of her look also helps. 300mm.

Tokina APO 80-200mm zoom lens.

Focal Lengths

Most people photography with telephotos is done from about 80mm to 200mm. Wider focal lengths than 80mm don't offer a big benefit for this work over a standard 50mm lens. Longer focal lengths usually magnify the subject too much and flatten perspective too much for most people shots (though they can be helpful in special situations).

- *80-105mm* — one of the most popular set of focal lengths for portraits; gives a nice framing of the subject from a moderate distance away; the perspective is pleasing on faces; depth of field is easily controlled.

- *135-150mm* — slightly longer focal lengths, common in zooms, and excellent for capturing people at more of a distance; especially good for "journalistic" studies because it puts more distance between the photographer and the subject than the shorter focal lengths, but doesn't have the stronger perspective and depth of field effects of the longer lenses; less used for portraits.

- *180-200mm* — the high end of many popular zooms, a useful set of focal lengths to capture "candid" people shots from a

85-100mm is a very nice focal length range for portraits. You can get a nice head and shoulders shot from a distance that won't make your subject uncomfortable. 85mm.

Left: Longer lenses, 200mm and up, can be very important when photographing events. They let you reach out and bring participants close even when you can't get right up to them. 200mm: 80-200mm zoom.

Below: Very long lenses (400mm and up) aren't often used for portraits, but they do offer some interesting creative effects, including very limited depth of field and strong perspective effects. 500mm.

moderate distance — they hardly know you're there; less used for portraits as the perspective effects are strong.

- *Above 200mm* — these focal lengths are mostly for creative effects; people's faces look flat if shot as close-up.

Up Close and Far Away

A telephoto makes it easy and convenient to get dramatic close shots of people, yet you can keep a little distance from them. This distance can be less intimidating both for the photographer and the subject. That will help make more relaxed-looking images.

Photographers are probably the only people to see everything at a middle distance. Or at least you'd think so from seeing most photos at a neighborhood photofinisher. And this is why so many people photos look the same and won't inspire anyone to want to know the people involved. The telephoto encourages you to get visually "closer" to your subject. That visual closeness will often add impact and power to your people shots.

A frame-filling face is a dramatic image because it features a person's eyes, the windows to a person's inner being. It also keeps distracting backgrounds out. A 100-200mm lens lets you do that without being too close to the subject.

A telephoto gets you visually "close" so you can show off the unique characteristics of your subject, plus control background size. 85mm.

Be careful when shooting a tight shot of a face, however, since depth of field will be narrow. If nothing else is sharp, the eyes must be. Out-of-focus eyes will ruin a face shot every time. This is where you have to pay close attention to your autofocus. Otherwise it may focus on the nearest part of the face instead of the eyes.

"If nothing else is sharp, the eyes must be."

The telephoto zoom is ideal for the casual portrait of a young child. It allows you to quickly frame the right composition before the moment is gone. 100mm: 80-200mm.

Eye-level

Besides shooting at middle distances, photographers often shoot everything at their own eye-level. The result is that short people shoot up to tall people and tall people down on short people. These angles give very different impressions of the subject.

The angle to the subject's eye-level is very important and needs to be considered carefully. If you look down on a subject, it makes them look small,

inferior and weak. Looking up at a subject makes them look big, superior and powerful. Those feelings may or may not be appropriate to your subject.

Start out by shooting at the subject's eye-level. This allows the person to look dignified without looking superior. Kids often look much better when shot at their eye-level because so often adults look down on them. Women get the "inferior" treatment when men shoot down on them, while men get a continued "superior" stereotype when women shoot up on them. Look for the eye-level shot.

You may want to shoot above or below a subject for compositional reasons. For example, shoot from below to get sky behind the subject or from above to see some low flower color in the background. This can be very effective as long as you don't overdo the up or down angle to the detriment of the subject.

Depth of Field and Perspective

The narrow depth of field of a telephoto can be put to great advantage when shooting people. Backgrounds will blur easily so the subject stands out quite nicely.

You must remember, though, that just because a background is out-of-focus doesn't mean it isn't noticed. Watch for distractions, such as areas that are too dark behind a dark subject or bright colors taking away from a fair-skinned face.

If you decide you want to see more detail in a background behind the person, you'll need to shoot at small f-stops to do any good. This usually means shooting on a tripod.

The flattened perspective of a telephoto has its good and bad points. It helps make backgrounds bigger, often making them easier to use behind the subject. It can also flatten out a face, making it rounder and "fatter"-looking, which is another reason the longer focal lengths are less used for portraits.

Portraits

The portrait is a time-honored way of formally capturing a person's likeness. The telephoto encourages you to get close-in images that really convey a person's essence.

While some portrait studios love to have a person looking airily into space, this is a very uninvolving, distancing way of making a portrait. As noted, eyes are critical. A direct look into the camera gives the subject a sense of presence and power. These direct eyes can be alert, playful, serious, concerned, or whatever else is appropriate, and they will show it. The moderate telephoto is ideal for this purpose.

Sometimes a look away from the camera is warranted. This makes the image less intense and a little less formal. But looking off into space is not the answer. Have the subject actually look at something, something important to them. This will give some life to their eyes and posture.

Action/Activities

One of the best ways to capture lively images of people is to shoot them when they're doing something they enjoy doing. This can be as simple as a grandparent reading to a child or as complex as a worker proudly performing his or her best work at a manufacturing plant.

Again the telephoto comes to the rescue. You often have less control over the setting when shooting people in action. The limited depth of field of the

"...eyes are critical."

The eyes are so very important to a portrait. Most of the time, you will want to shoot at the eye-level of your subject, no matter if he or she is an adult or a child. A direct look into the camera can give a strong sense of presence to the image. If your subject is looking away, be sure they are really looking at something and not staring into space. Focal lengths: 105mm (top, left); 80mm (top, right); 200mm (bottom, left).

Above: *A great way to capture natural looking images of people is to get them doing something they like, such as a grandson talking to his grandfather. 85mm.*
Bottom: *The limited depth of field possible with a telephoto lens keeps backgrounds simple, while the perspective effect makes it larger and brings it closer. 100mm: 80-200mm.*

tele can be used to throw backgrounds a little out of focus so that the subject stands out better. This means shooting at a higher shutter speed, too, so the action is more likely to be stopped as well.

This technique can be strengthened by using longer focal lengths. Don't use a 100mm lens because you think you have to be closer to the subject. Use a 200 or even 300mm lens, then back up. For example, suppose you wanted to photograph a performer at a Renaissance Faire — try backing up and use a long lens. The background gets softer and the performer stands out (and you the photographer are less distracting to the subject, too).

That longer lens will bring the background closer to the subject, too. This perspective change can make a shadow bigger for contrast or select elements of the environment that directly relate to the activity, for example, making the colors of flowers bigger behind a gardener.

Often a telephoto can make the difference between getting a shot or getting nothing because of limitations on shooting. Small, intimate events can easily be shot with a short telephoto of 100mm or less. Big events, especially public events, will often require a minimum focal length of 200mm. A zoom telephoto is ideal because you can vary the focal length, and therefore the framing, from a single position.

When you get in tight and fill the frame with faces, you gain some impact and power to an image. You can do this without sticking the camera into your subjects' faces when you use a telephoto. 85mm.

Electronic Flash

Flash is often prohibited at events, so be prepared to use fast films. Many news photographers rely on high-speed (ISO 800 and above) color print film for these conditions. This allows them to shoot in varied lighting conditions without filters, and get good color quality.

When flash is possible, the distances often require a flash unit with some power. A built-in flash will rarely do the job. With very long focal lengths (300mm and above), you can use "projected flash". There are a number of attachments available on the market that fit a fresnel lens in front of a small flash and concentrate the flash's power for long telephoto work.

"A built-in flash will rarely do the job."

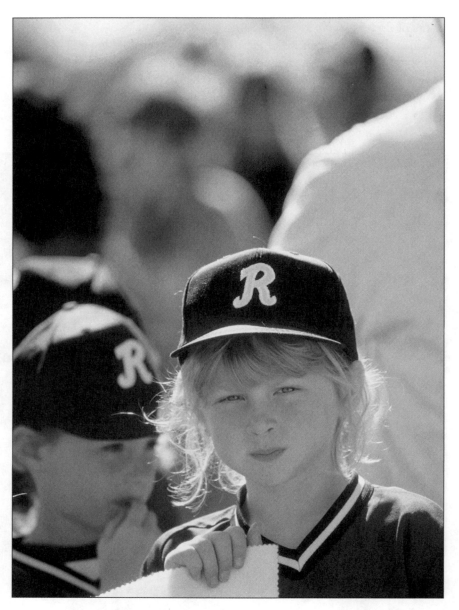

The longer telephoto lens lets you creatively play with out-of-focus shapes, tones and colors in the background, making that part of your image an interesting abstract. 300mm.

Chapter 6

FOCUS ON SPORTS ACTION

From the Super Bowl to the World Series, sports are a fun part of life and photography. Whole magazines are devoted to sports photography. For nearly every newspaper, from the high school monthly to big cities' dailies, sports are an important part of their photographic coverage.

For many sports scenes, just like wildlife photography, the telephoto is almost a necessity. Your vantage point is often limited, so you need the power of a long lens to pull in the action.

"...you need the power of a long lens to pull in the action."

Focal Lengths

Because the action of any sports event tends to have the subject moving quickly through the action area (soccer field, skateboard ramp, long mountain trail, etc.), you frequently need more than one focal length. A zoom can be invaluable here since it can reframe a moving subject quickly, even though you may be locked into position.

Autofocus lenses can be extremely valuable on cameras with predictive AF. Remember that you need to depress the shutter slightly to start the predictive autofocus going, then follow the action as you watch for the perfect shot. If you don't, the AF system will be hard pressed to catch up with the subject and have it sharp when you're ready to shoot.

Generally, just about any telephoto will work for some sport, but here's how a range of focal lengths will help capture sports action.

- *100mm* — for the close-in, recreational sports like in-line skating or when you are on top of the action (such as on the sidelines of a high school basketball game); too short a focal length for most "field" sports, except to show the field around the player, or when the player gets close to the sidelines in front of you.

- *180-200mm* — a good basic focal length for many sports action situations; this is in the range of many zooms. An 80-200 can be great for fast-moving action going across a field — you can zoom in to catch the runner on the opposite side, then zoom out as he or she comes close. The 180mm is usually a fairly fast single-focal length lens, which makes it ideal for available light shots at indoor sporting events.

- *300mm* — great to capture the Little Leaguer sliding into second or a downhill skier from down the hill. They also isolate the subject, compress distance and decrease depth of field, offering very dramatic images. The fast f/2.8 lenses are commonly seen at

Tamron 200-400mm zoom lens.

sporting events because of their extra light-gathering power. This allows faster shutter speeds to stop action, but these lenses tend to be big and expensive. If you're shooting a bright sun soccer game, you'll find an f/4 lens does just fine.

- *400-500mm* — important to football and baseball photo pros because they are often limited to a small area on the field but must pull in images from anywhere on the field, even at the other end; less used for kids sports or small-field sports because of the magnification. For small-town sports, like minor-league baseball, this focal-length range will give you portraits of the pitcher and then shots of the center fielder making the key play of the game.

- *600mm and above* — less often used in general sports action photography except for depth of field or perspective effects (shoot down a row of hurdles with a 600 and you'll see an obstacle course packed with horizontal bars); often seen at big pro-events.

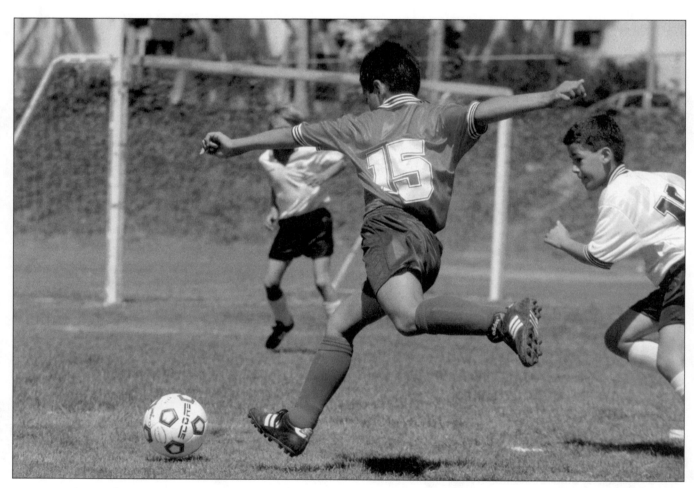

Fast-paced action moving across a wide field makes shooting soccer a real challenge. A telephoto lens can be a big help in framing the key plays. 200mm: 80-200mm.

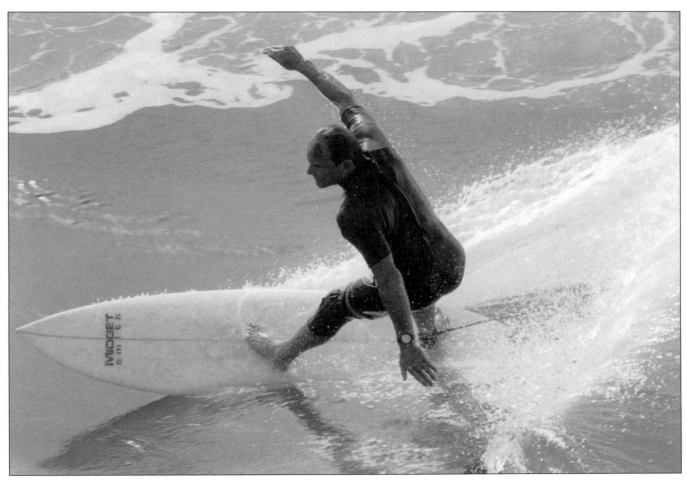

In many sports, your position is limited, so you have to have a long lens. With surfing, that usually means a minimum of 300mm as used in the photo above.

Specific Sports and Focal Lengths

While the photographer's field position will greatly influence the focal lengths needed, each sport favors the use of a certain focal length over another.

Baseball

Definitely a long lens sport, except for the very young kids. Since you can't walk onto the field, a 400mm is needed just to get a dramatic shot of action at second. You'll probably need an even longer lens at bigger fields to capture action across the field or in the outfield. You'll need at least a 200mm for good shots of the batter, simply because you have to be far enough away to get a good angle to the plate. Long lenses shot wide open also have the magical ability of making chain-link fences vanish. The depth of field is so low, that if you get your lens close to the mesh of the fence, it will disappear!

Basketball

Rarely will you need a long lens here. 80-100mm is an excellent focal length to capture the action at the ends of the court and also capture the action heading your way. Zooms are often so slow that even at maximum aperture, you may not be able to get a fast enough shutter speed.

"...each sport favors the use of a certain focal length..."

If you want to use a zoom, you'll need a faster lens such as an 80-200mm f/2.8 lens. Here's one place that the plain old short telephoto with its wider aperture can really shine. Even an 85mm f/2 lens adds a whole stop over an f/2.8 zoom, giving you another step faster shutter speed.

Football

Now we can come back to the zoom. For youth football played mainly during the day, one of the 100-300mm zooms can be ideal. The 100mm is perfect for the wider coverage of the huddle, the field goal play, and when the wide-receiver comes close to you. Often you can start with the zoom wide as the play begins, then zoom in on the key action.

That does take some practice, however. The longer focal lengths will let you zero in on specific players, such as the quarterback, and on action across the field. The longer focal lengths also give a dramatic perspective on the action coming toward you when you are near the goal line.

Hockey

Hockey has the speed and rapid back-and-forth movement of soccer in a space the size of a basketball court. Youth hockey varies from outside (you'll be more concerned about the cold than the light levels) where an 80-200mm zoom is ideal, to night and indoors, where you'll find a zoom is often too slow. The faster single-focal length lens of 100mm or so will capture a lot of the action, while a 180mm f/2.8 will zero in on the details.

Skateboard and in-line skating

You certainly don't need a long lens for shooting kids on skateboards or skates, although it can help. Backgrounds are often very distracting around a kid's typical skateboarding territory, but if you put on a long lens (200mm or more) and back up, the backgrounds will grow softer and less obtrusive. Competitions are difficult to shoot with anything except a telephoto — a moderate zoom (80-200mm) is ideal.

Soccer

This very popular sport among kids is a great challenge to shoot because the action is so fast, and it changes from one side of the field to the other in a flash. A zoom lens can help a lot, but you'll find full-sized fields consistently require 200-300mm lenses. A good place to be, if you're allowed there, is back by a goal. This allows you to get some very dramatic shots of the action coming right at you.

Surfing

Surfing is a sport that absolutely requires the longer lenses. You'll have a hard time capturing any dramatic images with less than a 300 or 400mm lens. Many pros shoot regularly with 500-800mm. The surf means you cannot get close to the subject, and even if you could, the straight on angle is not very dramatic. It doesn't show the wave as well as a shot from an angle, and the angled shot requires the longer lens.

Tennis

Tennis can be fun to shoot, since the compositions become so simple — a single player in lighter clothing against darker backgrounds. For casual players,

"This allows you to get some very dramatic shots of the action coming right at you."

you can usually get very close while they are warming up. You'll need to back off when the play actually starts since a photographer can be very distracting. An 80-200mm zoom will allow full-length shots as well as close-ups of the action from a position a little off of mid-court.

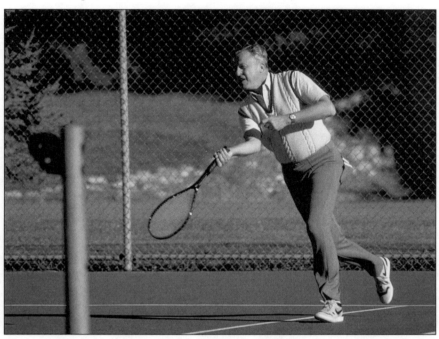

Tennis has a lot of action, but it is fairly predictable. Single-focal length lenses work fine with this sport. 300mm.

Track and field

Most events will look best with a longer lens, even if you can get close, just because of the lens' ability to soften and simplify the often busy backgrounds of a track meet. Look for dramatic angles with a very long lens (300mm and above) for very effective shots of athletes heading toward you. A moderate zoom of 80-200mm will work for most of the events if you can get close, as long as you use the full range of the lens.

Practice Makes Perfect

Just as in playing sports, good sports photography demands practice, both to master it when you're learning and to keep up your skills after you've gained some experience. One of the best ways of doing this is to shoot kids sports for fun. They move quickly, demanding that you learn to operate your camera quickly, and you can almost always get close to the playing field.

Getting practice this way will give you a feel for the game and for where most of the action occurs. It is a very different thing to watch a game strictly as a fan versus watching it for good photographs.

This will also teach you to anticipate and react quickly. You must have an idea of what's developing on the field so that you can be prepared for the action. If you've got a telephoto trained on second base when the action is the kid on third stealing home, you not only will miss the shot, but you might not even know anything is happening until it is over.

"...good sports photography demands practice..."

Telephotos definitely limit your field of view. It helps to learn to sight over and around your lens. Then you can watch for action as it develops on the field, instead of just as it develops in your lens. Once a promising action starts, you need to follow it through your viewfinder, ever vigilant for the detail that really says something about the sport.

When you can move around the field, watch the action and see where most of it seems to be occurring. For one baseball game it might be second base, another the pitcher's mound. A kids' soccer game will very often keep most of the action at one end or on one side. Move around, looking for the best angle and good telephoto backgrounds (remember that the telephoto gives a different look to backgrounds).

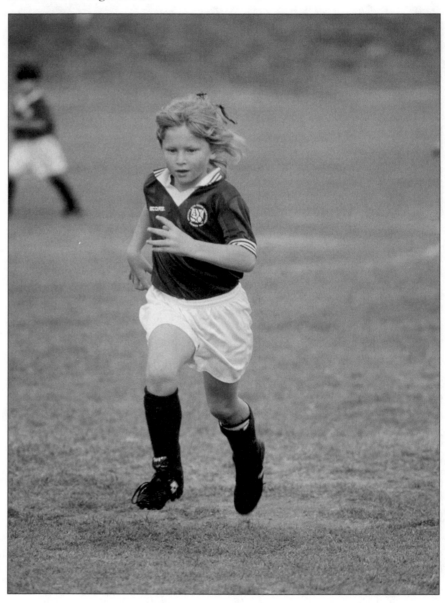

Modern autofocus cameras are a great help in keeping your subject sharp as she moves down the field. This also makes using a zoom easier as you can zoom and trust the camera to focus. 300mm.

Anticipate

Most sports action happens so fast that if you wait until you see the action in the viewfinder, it will be long gone by the time the shutter goes off. Your best bet is to start shooting before the action hits its peak. That means you must watch the game for a while to understand where the action ebbs and flows. The worst thing to do, unless you totally understand the sport, is to start shooting at the opening buzzer.

Always go to a sports event with lots of film and be prepared to shoot it. You will almost always miss peak action if you stingily shoot only when the action is hot. If you don't have the film to burn, watch where most of the key plays occur, then shoot when the action heads there. Forget the rest of the playing field, regardless of what you might miss and simply concentrate on getting the most from your film supply.

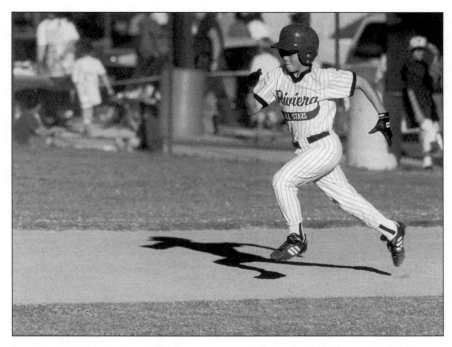

You must anticipate action for good sport shots. Watch the game looking over your lens, but with camera and lens set and ready to go. 300mm.

Special Moments

Sports include a lot of intense action, and emotions run high. There are important moments on and off the field when sports "action" may be best defined by a special moment when no rapid plays are in motion.

A 200mm or longer lens is ideal to capture the times of exhilaration and excitement, the periods of exhaustion, and the expression of defeat and loss that always accompany sports. Images captured at these times can be as important as the key play that saved the game.

Think of how a tennis player grimaces in frustration at a missed shot, a baseball player jumps with joy at a home run, a soccer player slumps in exhaustion, a running back holds hands high in jubilation, and so on. The telephoto lets you capture these moments without disturbing the participants.

"...can be as important as the key play..."

Chapter 7

LANDSCAPE IMPRESSIONS

Many photographers believe landscapes are best photographed with a wide-angle lens. The spread-out vistas, the broad horizons, the opportunities for interesting foregrounds and backgrounds, all seem to call for focal lengths wider than the standard 50mm.

The telephoto, though, offers new and dramatic ways of looking at the landscape. By using one here, you'll find your creative vision is expanded.

Landscapes aren't just for wide-angle lenses! Telephotos can emphasize vistas, compress distances and add to your creative possibilities. 200mm: 80-200mm zoom.

Focal Lengths

Landscapes don't fit the pattern of the other subjects in this book. Every landscape reacts differently to different focal lengths, and a variety of focal lengths will often work well on a single landscape. An excellent exercise is to try to find as many compositions as you can of a landscape, using all the telephoto focal lengths you have with you.

Some good focal lengths include:

- *80-200mm* — range of the typical mid-range zoom; long enough to focus in on details, yet wide enough to show some of the surroundings; won't overemphasize haze too much.
- *300mm* — excellent for distance compression effects that aren't too abstract; will really focus in on distant details; strongly affected by haze (and will intensify fog).
- *500mm* — flattens out landscapes and compresses distances — effect can become rather abstract; sun starts looking large at the horizon.
- *600mm and above* — big sun focal lengths; can simplify a landscape by isolating distant details; tendency toward abstraction.

Canon Zoom lens EF80-200mm 1:4.5-5.6.

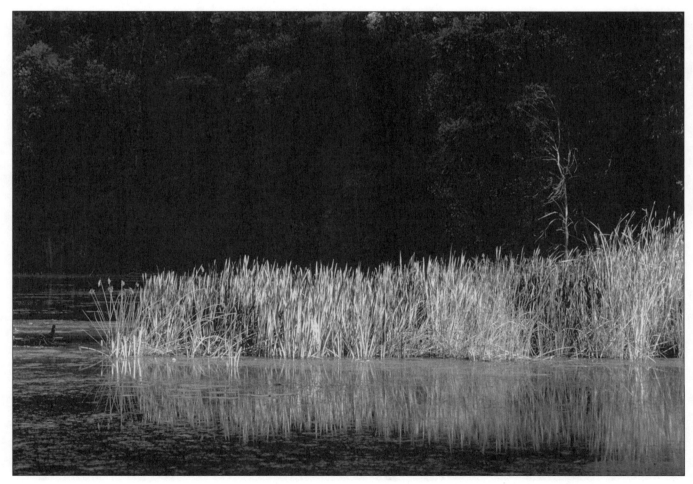

A simple scene only possible with a telephoto lens — it isolates the nice light on the cattails, while enlarging the background to fill the rest of the frame with a dark tone. 300mm.

Extraneous Details

One of the biggest challenges in everyday landscape photography is to capture a landscape free of distracting details. Our world today is filled with man-made objects that can compete with the beauty of a landscape — stop signs, power poles, roads, chain-link fences, fast-food restaurants, etc. You can often appreciate the beauty of the scene even with these distractions when you're standing there. When they're included in the photograph of the scene, they're most annoying. The viewers of your images will notice.

The telephoto comes to the rescue, even in areas of high potential distraction. For example, many Western cities have beautiful mountains surrounding them. By putting on a moderate focal length, you can often capture a great image of the sunset and mountains from the parking lot of your motel, even though there are a myriad of neon signs all around. The telephoto isolates the mountains and sky, and eliminates the signs. A zoom lens is ideal for this. You can zoom in until the distractions just disappear at the edges of your viewfinder. It's always a good idea to check those edges to be sure that things don't creep in that might cause your composition problems.

Sometimes you know there's a photo out there, but you can't get close enough to your subject. The area around a waterfall might not have any ugly signs or roads, but you can't get close, so photos with a standard focal length

This striking cliff was separated by cornfields from the camera position. A moderate telephoto cropped out extraneous detail (a polarizing filter emphasized the sky). 135mm.

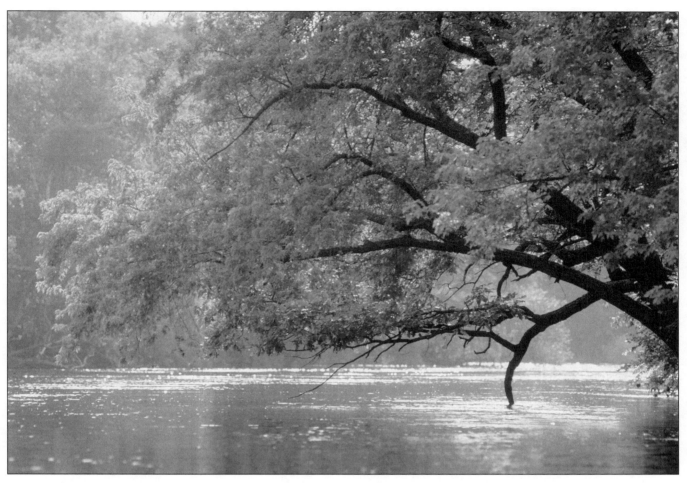

A detail of light and dark, water and trees, in the landscape is made possible only with a telephoto. Even if you could shoot from a closer position, the scene would look different. 400mm.

include too many boring rocks or trees. The telephoto again allows you to capture the part of the scene that is most important to the composition.

Isolating Details

Sometimes a landscape looks great with wide-angle lenses, but there are interesting details within the broader scene that look great by themselves. While a sweeping view of the Grand Canyon might make a wonderful image, a narrower view emphasizing the rock details might more appropriately reflect how you are experiencing the sight. You can control what you want a viewer to focus on, what they see and what they think of the landscape.

Perhaps you find certain colors more interesting. Maybe it's the forms of the rocks in the stream bank. Concentrate your composition on them with your telephoto lens. Important details of a landscape will vary depending on the photographer. The geologist shooter will see something different than the botanist. That kind of detail, detail you care about, can make your photos more interesting. Don't point out barely seen details in a wide-angle shot if they're important to you. Shoot them while you're there with your longer lenses.

Very long lenses, those 500mm and over, can give some highly stylized, isolated imagery of the land. At first, the scenes will be hard to see in the distance.

"You can control what you want a viewer to focus on..."

Put that camera and lens on the tripod and check out the scenery by looking through them.

Compressed Distance

Telephotos compress distance, making distant picture elements seem closer. This can dramatically create landscape images with a lot of creative impact. Look for distinct areas of a landscape that can be moved together for effect: ridges on a mountainside, colorful trees in bloom, big rocks in the desert, anything that looks interesting when compressed.

This effect is often hard to visualize when you're just starting to explore telephoto's and the landscape. The best thing to do is put the camera and long lens on a tripod and search the landscape for interesting compositions. After a bit, you'll start to see the compression without the camera.

Usually, you'll need 200mm and more to really gain the most from the compression effects. A 300mm is ideal.

Perspective Changes

The telephoto offers some genuinely striking effects on perspective. You can totally abstract the land from the real landscape, or you can simply change the viewer's impression of space.

Depth control is a very important creative tool for the landscape photographer. Very often you need to bring interesting elements of a scene together. For example, a nearby boldly-lit fall tree with a rocky hillside in the background. The longer the focal length, the farther back you'll need to be to get the whole tree, but the bigger and closer the background rocks will appear. Even though the tree is framed properly with the 80mm end of your zoom, you may find the image is more effective if you zoom in to 200mm and back up until the tree is properly framed once more.

Fence posts, rocks, a stream bed, things going off into the distance will look like they're closer together with a longer lens. This is an excellent way to mass color from flowering plants or trees. The telephoto brings them together in such a way that spaces between them aren't as noticeable, and the flower color gains more impact.

This will also make distant mountains loom over a small foreground element, such as an interesting rock formation. The size relationship is actually truer to reality than anything you could shoot with a wide-angle, because the rocks will appear realistically small compared to the large mountains behind.

Look for ways of using the telephoto on the landscape. Too often, photographers see an interesting subject in the landscape, then move in close to make the subject look better. A long lens will get you visually close and will often offer you a better perspective than if you move physically closer.

A wide-angle lens will reduce the size of all other picture elements in the background. This isn't necessarily the best way to approach the scene. Look at the subject from afar with a telephoto lens and see if it doesn't relate to the environment in ways maybe more appropriate to the scene.

Fog and Haze

One problem with this change of perspective and compression of distance is that the lens will compress all the air it shoots through. On a clear day, that's of little importance. If there's any haze in the air, it will be emphasized. A landscape can look crisp and clear with a wide-angle lens because you're close to

DEPTH CONTROL

Affecting the depth or change of subject/background relationships in a photo. One potent tool for doing this is changing focal lengths of lenses.

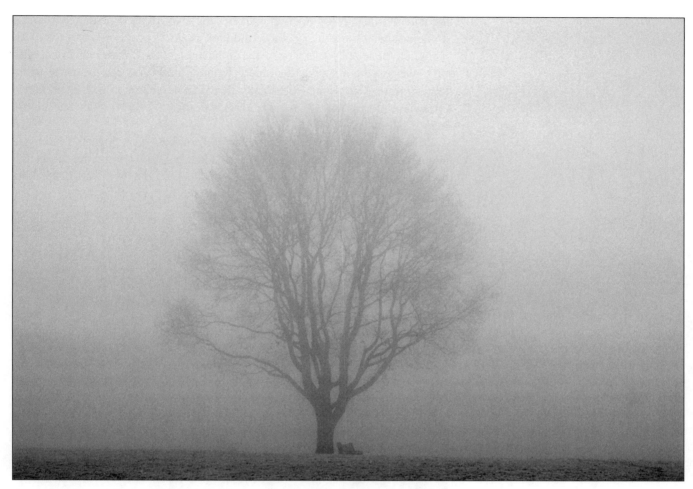

Fog is enhanced with a telephoto lens by making the fog in the background bigger and emphasizing the moisture of the air. 105mm.

the picture elements. The same landscape can look extremely hazy shot through a long lens. This haze effect can be awful or great, depending on your intentions. Midday, backlit haze on spring flowering trees might be too extreme shot with a telephoto because it dilutes the pale colors. On the other hand, a light morning mist on a lake might actually look too thin with a wide-angle lens, but look rich and moody with a telephoto.

Exploit the haze early or late in the day by aiming your telephoto toward the rising or setting sun. This will add a rich color to the atmosphere and create interesting planes of landscape elements. When shooting print film, tell the processor you have done this and to leave the color alone. Automated printing machines will often try to take this color out, making the scene more neutral than it really is.

Fog can be intensified, too, for very interesting effects when the sun can't be seen. The color of the fog will be intensified by the telephoto, but it is often difficult to predict. Our eyes tend to compensate for the color so that fog looks gray to us, but the film will record everything from neutral gray to pink to blue-tones. Try it and be surprised when you get the film back.

Sunrise/Sunset and Big Suns

Sunrise and sunset are perfect times to be out photographing the landscape because the light is low and highly directional, giving nice depth and form to

"Try it and be surprised when you get the film back."

the land. It is also colored, offering interesting color harmonies and contrasts as it interacts with the colder color of the blue sky.

When the telephoto exploits haze in the air, and the colored light of sunrise or sunset can be a wonderful way to bathe a landscape in a beautiful warm tone. Sunrises tend to have less color that is more yellow in hue. Sunsets will often have more color that is more strongly orange. All sunrises and sunsets are unique and will vary.

The color of the sky can be emphasized, simply by putting on a moderate telephoto. This allows you to eliminate the dark blue sky around the sunset and frame only the bright colors you want. Try this on a day with varied breaking clouds and you'll find amazing color compositions all over the sky.

The big suns of landscape photography are also important to travel shots. A lens in the 300mm range will give some connection between the sun and the surroundings. 300mm.

For exposure, meter the sky beside the sun, but not including the sun. Big dramatic suns can be fun to do in a landscape image, but they require very long focal lengths. The sun starts making an impression with a focal length of 300mm. Great effects come from 500mm and up.

Here's one place that a teleconverter's shortcomings have little effect. A 300mm with a 2X converter can be a great 600mm combination. You have plenty of light, so you don't worry about the loss of f-stop. You can easily stop the lens down for more sharpness. If the sharpness isn't perfect, it probably won't matter because the contrast of the scene is so overpowering.

The big sun looks best when down near the horizon, where it can relate to something. Put it behind rocks, mountain tops, trees on the horizon, etc. Be prepared to start shooting as soon as the sun comes close to the horizon. The first time you try this, you'll be surprised at how quickly the sun disappears.

Just as with simpler sunsets, meter the sky beside the sun. As you shoot, don't stare at the sun through the lens. This will cause problems because the lens concentrates the sun's rays into your eye and can cause damage if you keep your eye to the viewfinder. It's best to lock your camera to a tripod, frame up the composition, then shoot as the sun goes down, only checking occasionally through the viewfinder.

Shutter Speeds and F-stops

As mentioned earlier, telephotos magnify camera movement and can cause serious unsharpness problems. This is particularly a challenge with landscape photography, since some of the best images come at times of lower light.

You may need small f-stops to gain as much depth of field as possible. Remember that telephotos reduce depth of field, often the opposite that's needed in a landscape.

You can stop your lens way down to f/16, f/22 or smaller, and achieve your focus objectives. The problem is the shutter speed. You may end up with very slow speeds highly sensitive to vibration.

Several things to try:

- Avoid 1/15 sec.
- Use a cable release (or camera remote switch).
- Stay out of the wind (find some protection, perhaps behind a rock, a car or a tree).
- Use a heavy tripod.
- Add weight to the tripod.
- Add another support (mount the lens to the tripod, then put a monopod or stabilizer attachment under the camera). This is awkward to move around, but it really does work.
- Lean on the tripod (usually you'll hear you should never touch the tripod, but if it's windy, you'll need to do something to dampen the movement).
- Use faster film.
- Shoot several shots of every subject. Often one of a group will be sharper than the others.

> "The big sun looks best when down near the horizon..."

LOW-LIGHT LANDSCAPE PHOTOGRAPHY:

- Avoid 1/15 sec.
- Use a cable release
- Stay out of the wind
- Use a heavy tripod
- Add weight to the tripod
- Add another support
- Lean on the tripod
- Use faster film
- Shoot several shots

Chapter 8

TRAVEL ANGLES

From visiting relatives on the other side of the country to exploring new cultures on the other side of the world, travel can be a stimulating experience that encourages photography. It takes you out of the familiar and into new settings with a wealth of creative possibilities.

Unfortunately, travel photos don't always evoke the drama of the setting or the feelings the photographer had when there. The telephoto can help by encouraging you to find new vistas in your viewfinder.

Focal Lengths

With travel, you're often limited by what you can carry with you. So, the telephoto zoom becomes an important companion.

The Pentax IQ Zoom 160 camera. This is a telephoto point and shoot camera.

- *80-200mm* — good all-around set of focal lengths for the travel telephoto (many zooms cover this range); the 80/100mm end gives nice framings of "groups" — of people, buildings, historic artifacts, etc.; the 200mm end is great for capturing details, isolating graphic picture elements, or some types of candid people photography.
- *300mm* — a little extra magnification for those quaint rural buildings/landscapes or church on the distant hill; will really isolate people from a crowd because of the narrow depth of field possibilities.

Many photographers are attracted by the extended-range zooms that go from wide-angle to moderate telephoto (e.g., 28-200mm). While these lenses do include focal lengths very useable in travel work, they do have some distinct disadvantages:

- They are big and heavy. A compact 80-200mm and 28-80mm set of zooms are more to carry, but individually, they are quite a bit smaller and lighter on the camera and around the neck. Plus they are easier to handhold for sharpness.
- They often have lower optical qualities. The expensive extreme zooms with special lens glass are excellent. The less expensive ones tend to vignette (darken the corners) when shot wide-open at wider focal lengths and rarely match the image quality of zooms with shorter ranges.

Houses, Buildings and Other Structures

One of the wonderful benefits of travel is the chance to experience the variety of places where people live, work and play. But often, buildings just look like buildings in the picture and nothing really special. The telephoto gives you the chance to focus in on what really interests you about the structures. As you

Above: Buildings are just buildings, not photographs, unless you look for a special way to see them. Here, the setting of trees isolated by a moderate telephoto provides a frame for the capital at dusk. 100mm: 80-200mm zoom.
Below: The receding lampposts create interest on a California pier at dawn. This interesting design is only possible through the perspective changing ability of a telephoto. 200mm: 80-200mm zoom.

Above: *Wildlife photography requires long lenses. There is no way around that. But once the animal is in the viewfinder, you still need to look for the photograph of interesting color, light, composition, etc. 300mm.*
Below: *Very long lenses make for very dramatic suns. Be prepared for the sun to set quickly once it nears the horizon. Never stare at the sun through a camera with a telephoto lens. 500mm.*

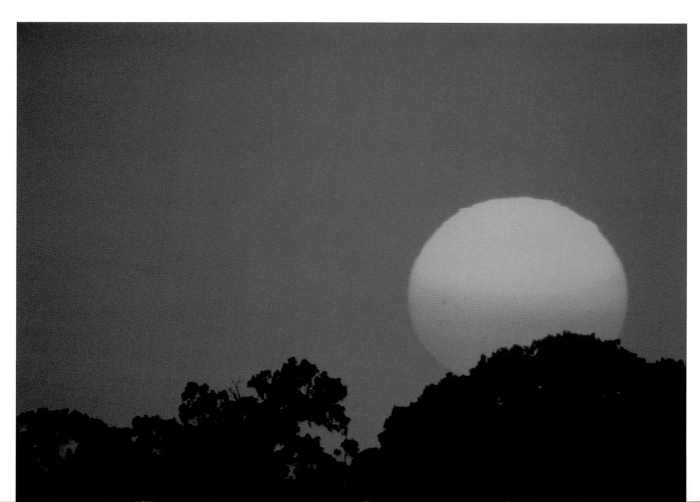

Above: *Many people believe that only macro lenses can be used for close-ups. Not true! Stick an extension tube on any telephoto for some great close-up imagery. 300mm plus an extension tube.*
Below: *The moderate zoom is ideal for travel as it allows you to get a variety of compositions from one spot (sometimes from a position you cannot change). 100mm: 80-200mm zoom.*

Left: *Even in the studio, a long lens can be an effective tool. A 300mm lens compresses the image and changes colors in the foreground of this cat portrait. The lighting is a softbox on the right plus a fill bounce light by the camera. 300mm.*

Bottom: *Studio close-ups can benefit from the compression effect of a telephoto, too. Here the colorful bolts look closer together, becoming a small forest of bolts. 100mm macro.*

come upon a scene, the short telephoto (80-100mm) will often let you see the buildings in place with others, providing a nice environmental shot.

That particular perspective is unique to the focal length. This short telephoto range is short enough that the extreme telephoto effects aren't part of the image. Yet it's long enough to avoid the problem of lenses 50mm and wider.

The wider the lens, the closer you have to be to the subject. The subject begins to dominate everything else and doesn't seem so much a part of the setting. Also, as you get closer, you have to change your viewing angle, looking up on the subject. This causes parallel lines to converge, making buildings lean backward (an interesting effect — but only if you want it). And it causes buildings behind the subject to disappear because the subject blocks the view.

Sometimes, it's worth putting on the moderate telephoto, then moving back to include the important part of the scene. This works really well if you can shoot from a little height, such as a hill, some stairs, a fence, a car bumper or whatever is available. Of course, there are times that you have no space to move back, but look for opportunities to try this.

Longer focal lengths will create more flattening of the scene, stacking buildings up against one another. This can be a terrific effect, but it isn't always possible, simply because you can't get enough distance between you and the main buildings and still have a clear view of them.

"The wider the lens, the closer you have to be to the subject."

The sun glints from a distant building, a detail that would be lost with a wide-angle lens. The "starburst" comes not from a filter, but from stopping the lens down to f/16 or f/22. 150mm: 80-200mm zoom.

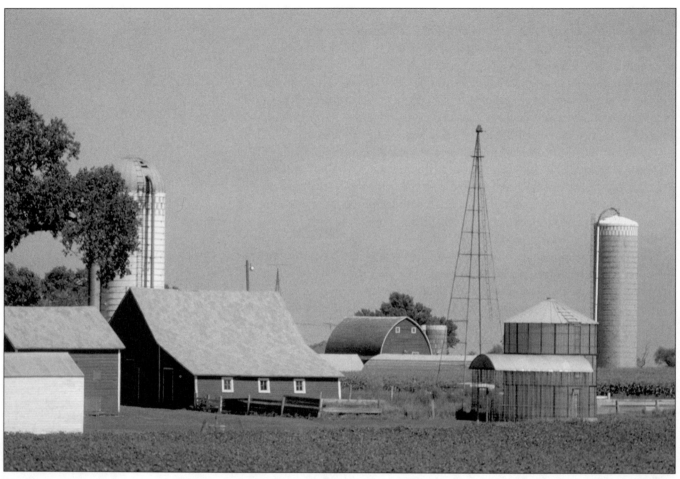

By flattening perspective, a long lens creates an almost abstract patterning of shapes that we know because they are farm buildings. 300mm.

This effect is often very useful out in the countryside, where you can compress farm buildings against attractive scenery. Look for the chance to do this as you approach the buildings — it's hard to visualize when you're right there in amongst them.

You can always use longer focal lengths to zero in on great architectural details. Often, these details are what make a structure so fascinating. While a big Gothic cathedral is dramatic, all its details really give the effect — the carved figures, the stained glass, the stonework, and more.

Even a simple thatched hut has its fascinating details to be seen through the telephoto — the thatching, the corner construction, the framing around the windows, the live plants growing in the roof, and so on.

You may need a wider shot to show what the whole structure looks like, but the details will give your photos a special impact. And they'll tell the viewer what is really special about this architecture.

Put on the longer lens or zoom out to the 200mm setting and start checking out the scene. Signs can be fascinating when isolated this way. Or how about historical artifacts (such as a cannon barrel protruding from a fort wall)? Or maybe you find the colors of a culture fascinating and can focus on flags or painted shutters.

Perhaps it's the details in the "accessories" of a building — the filigree of a cast-iron fence, the weather vane on the roof ridge, the gargoyles of an office

building. Think details and how they reflect on your experience of the location. The telephoto will encourage you to capture them.

People

People are an important element of any travel location. The differences in people can be seen whether you're comparing Minneapolis to Boston or Washington, D.C. to London or Moscow.

Many of the ideas presented earlier on people photography also apply to people in a travel setting. The biggest difference is that frequently you will be photographing strangers, and not everyone is comfortable with that.

There are two main ways to deal with people under these conditions:

- Photograph them when they are aware of you
- Capture their images candidly when they are going about their business

The moderate focal lengths are best when you go for the portrait of the side-walk vender or the street performer. Street performers often enjoy having their photos taken and will give you great action shots if they know you are there. However, in some highly traveled locations, they will expect a tip.

Other people going about their business will often consent to a photo if you politely let them know how attractive you think they are (even if you have to do this in a sort of sign language if you can't speak the native tongue) and how pleased you would be if they would let you take their photo.

Don't make a big production out of the shot, though. Have your camera ready — proper focal length attached or set, exposure set, flash ready. Then smile, bring the camera up and take a few photos. One photo is rarely enough, since people often over-pose or over-stiffen for the first shot, then relax a bit for the subsequent shots.

Longer focal lengths are helpful if you want more candid images where you don't disturb the individual. But even a 300mm lens will do you no good if you are too obvious about your business. Many photographers try to find a spot to sit down, or lean against a tree or column, then become part of the crowd, so they can casually take some photos.

Don't "stare" with your lens. Too often travelers do this, pointing their long lenses at a likely subject, then standing there unmoving until everybody knows what they're doing.

Watch the subject, look for interesting action, have your camera in your hands at the ready, then bring the camera up when appropriate. Remember that the camera is coming from movement, so stabilize the equipment before squeezing off a few shots.

Take several shots, drop the camera and wait for more action, then repeat. This studied casualness will cause you to blend in (as much as you can in a foreign setting) and make the candid shots truly candid.

Marketplaces

A marketplace is a wonderful place to explore with your camera, whether it's the waterfront market in Seattle or the street-filling bazaar in Morocco. There you will find colors and forms, details and textures, people and faces that can really give an impression of a different place.

Wider-aperture telephotos can help because light levels are often low here. In addition, try the newer high speed films to keep shutter speeds high and look for places to brace your camera. You'll rarely be able to use a tripod or

"Watch the subject, look for interesting action..."

other support, but the back of a bench, a mailbox, a post can all stabilize your camera if you lean it against them. A small bean bag is very portable and can help you hold the camera against many surfaces.

Details here can be overwhelming. Try picking an interesting spot, then put your camera to your eye and explore the food, the crafts, the faces, the colors with a telephoto view. With practice, you'll start seeing these things even before you pick up your camera.

People at Work

While people's dress and habits tend toward more global "lifestyles", their occupations continue to vary considerably. This can make for exciting travel imagery, whether the jobs are mundane or exotic.

The telephoto is almost a necessity here, and sometimes, the longer the better. Frequently, you can see interesting work, such as the Asian traffic cop in amongst the swirling cars or the ship painter working high on the side of a ship, but you cannot get physically close.

The telephoto with its capability of narrower depth of field can also help isolate workers from busy surroundings, so you can compose a clearer, more dramatic image.

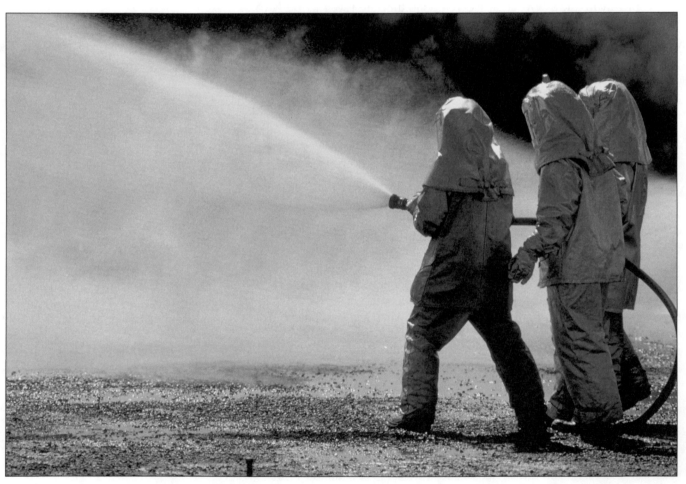

The telephoto does a wonderful job of isolating people at work from busy surroundings, plus it keeps you out of their way. 300mm.

Left: *Focal length greatly affects the angle when photographing a building. A wider lens, like the 80mm used for this shot, means you must be close and look up for the composition. 80mm: 80-200mm zoom.*

Below: *A much longer lens, on the other hand, forces you to back up, looking more horizontally at the building, giving more context to the structure's setting. 300mm.*

Sunrise and Sunset

The big suns of landscape photography also look great with travel shots — a big sun setting behind a country church, for example. You get them the same way, by having a long focal length and being ready as the sun gets close to your subject.

For travel, you'll probably won't need the extremely dramatic huge suns, so you can get away with shorter focal lengths, such as 300-400mm. A tele-converter and an 80-200mm zoom can make perfect travel companions just for this purpose.

Overall, sunrise and sunset can be gorgeous times to show off a travel scene. The low light makes the textures of buildings and roads really come alive. This highly directional light also gives interesting shadows and three-dimensional form to a scene.

The color of the light will add interesting colored highlights to your images, making the windows of a historic building glow, edging exotic animals such as camels or lions with golden light, and giving new dimension to landmarks.

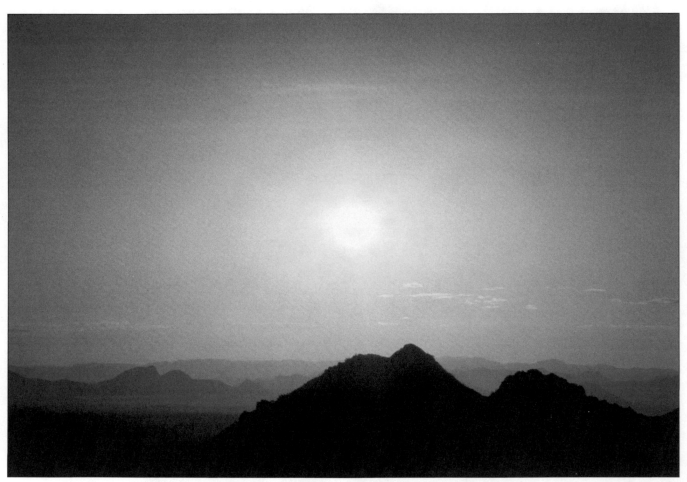

An early sun backlights Arizona mountains while adding a touch of brilliance to the scene. The contrasts of silhouetted peaks and hazy ridges give depth to the landscape. 200mm: 80-200mm zoom.

Night

Many locations come alive at night. But one problem is that night light can be too dispersed for a wide-angle lens.

The telephoto allows you to concentrate on the night color of Las Vegas or the street scenes of Tokyo. But remember, it is also very sensitive to camera movement. Night scenes are low-light situations that demand slower shutter speeds.

Look for ways to brace your camera for the longer exposures. Use a tripod or monopod if you can. Look for a signpost to lean against or a fence to rest your lens on. That bean bag mentioned earlier can be a real help here.

Watch out for exposures a second or longer. Many films actually change their sensitivity characteristics with longer exposure and become less sensitive to light (this is called reciprocity failure). If in doubt, double the exposure. At night, a little extra won't make the dark areas of night any lighter.

"Look for ways to brace your camera for the longer exposures."

Chapter 9

TELEPHOTO CLOSE-UPS

With so many photos in our world, how can you get other people to pay attention to yours? A close-up is one magnificent way to do this. Close-ups take people into worlds they don't normally visit, isolating and magnifying subjects rarely studied with such intensity.

Research shows that most photographers shoot at moderate (5-8 feet) and far distances (infinity), so a close-up or macro shot (a very close close-up) automatically breaks creative bounds.

This chapter will show you how to expand your close-up opportunities by using the longer focal lengths for nearby imaging. This can add a lot of to your images.

"...expand your close-up opportunities..."

Focal Lengths

Every focal length can be used for close-up/macro work. This runs counter to what you often see associated with close-up images.

To select a focal length for close work, you need to understand how focusing distance affects your photography up close. To get a close-up of a flower with a 50mm or wider lens, for example, you have to be very close to the subject. But you can back off a bit with a telephoto. This permits more possibilities for light and lighting, because if you are too close, you will shade your subject. It also puts some distance between you and skittish or dangerous subjects.

Another close-up challenge is that perspective and depth of field effects from a telephoto focal length are greatly intensified, but that also opens up some wonderful creative possibilities. You can actually use every possible focal length on close-ups for very different creative potentials:

Sigma 400mm APO Macro lens.

- *80-100mm* — excellent all-around focal length for close-ups. This gives you some focusing distance to work with, making it the minimum for getting close to small creatures like butterflies. It also has excellent isolation characteristics (shallow depth of field and flattened perspective) for shooting flowers and other sedentary subjects. There are actually several macro lenses in this range. A macro lens is specifically designed for high sharpness when used up close, and can be focused from infinity to its closest focusing distance with no added accessories. That makes a macro lens very convenient.
- *150-200mm* — great focal length for wary small critters, from butterflies to lizards. It's still got some depth of field, and it's handholdable. It'll even keep you away from dangerous subjects, such as a scorpion or a heavily prickled cactus.

- *300mm* — now you start to see some truly magical effects up close; backgrounds literally disappear into a blend of out-of-focus color; depth of field becomes extremely narrow; the focusing distance is large and you get excellent magnification from afar.
- *400mm and above* — although not used a lot with general close-ups, these focal lengths offer some wonderful abstract effects because of extremely shallow depth of field and flattening of perspective. You can literally shoot through closer objects, so that all they leave is a creative blur of color. For small wildlife close-ups, songbirds or small mammals, these focal lengths are very important.

Getting Close

Getting close with a macro lens is easy. Put it on the camera, go close and focus. However, getting close with a telephoto often isn't. Most longer-focal-length lenses don't focus overly close. With the right accessories, though, you can make any telephoto focus close. A close-up lens (sometimes called a close-up filter because it screws onto the front of a lens like a filter) changes the focusing ability of a lens so it can focus up close. It comes in varied strengths and doesn't change the amount of light that reaches the film like other close-up accessories do.

MACRO LENS

A lens specially corrected for optimum performance at close-focusing distances.

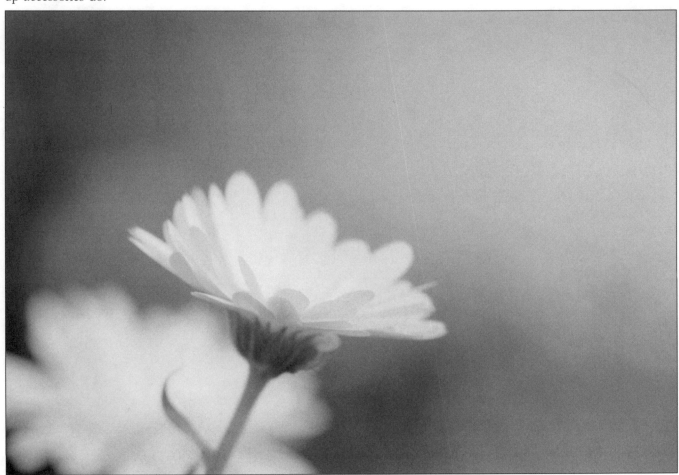

Long lenses offer some truly magical effects up close as backgrounds disappear into a soft blending of color and tone. 300mm macro.

Close-up lenses are inexpensive and highly portable. They do the job, but most of them degrade the image quality of the lens. This is especially noticeable at wider apertures, around the edges, and with stronger close-up lenses. Since they are simple, exposed lenses, they are easily scratched or broken.

There is also a special challenge here. Telephoto lenses often have large filter sizes, demanding large diameter close-up lenses. Often, you won't be able to adapt standard-sized filters or close-up lenses to a telephoto, and you'll need to buy a whole new set for the larger lens.

Some manufacturers offer a corrected or multi-element close-up lens especially for longer lenses (examples include Nikon, Canon and Hasselblad). These lenses can be mounted to any lens that has a similar filter size (using step-up or step-down rings or adapters as needed — they allow filters to be attached to a variety of lenses, even if the close-up lens was not made by the same manufacturer). Because these are optically-corrected lenses, the image quality is quite high.

Extension tubes are probably the most versatile accessory to help you focus closer with a telephoto. These tubes have no lens elements in them. They are literally empty tubes with linkages for the camera and lens automation. This makes them very rugged and durable.

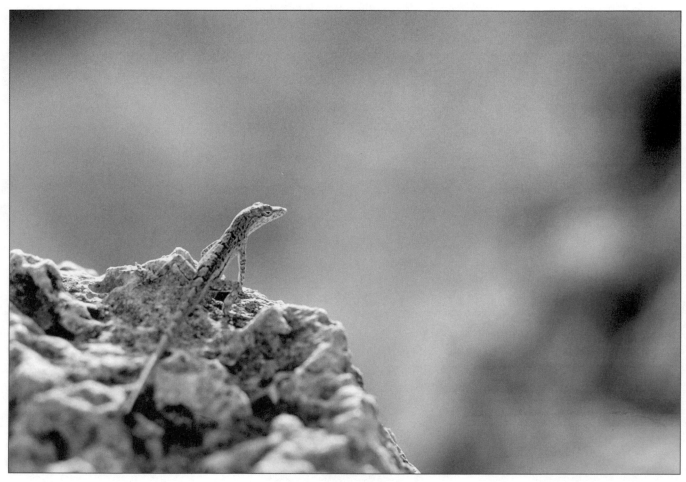

For small critters, a long telephoto plus extension tubes may be the only way to get the shot. These animals usually won't let you approach even with a 100mm macro. 300mm plus extension tubes.

They fit between the camera body and the lens to increase the space from film plane to lens elements. The bigger this distance, the closer a lens can focus. For telephotos, you will need the longer extension tubes to have much of an effect — this is especially true for the longer focal lengths. Extension tubes do their work in relationship to the millimeters of focal length of the lens.

These tubes will work with every lens you own or will ever own within a particular lens mount. They are great for zooms because you can actually change focal lengths for close-ups (many zooms have a "macro" setting, but this is often only at the widest focal length). Don't be alarmed when you find your zoom loses its focus as you change focal lengths up close. This is normal. Extension tubes change a lens's ability to focus up close because different focal lengths will have different focusing distances.

Extension tubes give the maximum sharpness possible from a given lens. Lenses vary in their ability to maintain sharpness up close. Often, faster lenses

"Lenses vary in their ability to maintain sharpness up close."

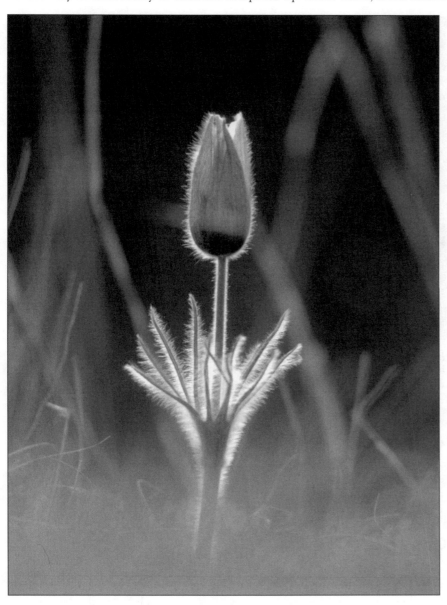

With long lenses, you can literally shoot through the foreground, creating interesting out-of-focus tones and colors. 300mm plus extension tubes.

"There is always a light loss when using them..."

have problems keeping their best sharpness at close-up focusing distances — the slower, cheaper lenses are the ones that pull through.

There is a downside. Extension tubes "eat" light. There is always a light loss when using them, a loss that must be compensated by a wider lens opening or a faster shutter speed. (This is also true for macro lenses, however.)

The amount of light lost varies depending on the size of the extension and lens, but is always there in some degree. TTL autoexposure systems will adjust for this, but you may lose the ability to use desired shutter speeds or lens openings.

A teleconverter also brings images in closer. It does not change the lens's ability to focus closer, but it does magnify the image at whatever the lens's closest focus is. The image is visually closer, giving the effect that you focus closer. Teleconverters still cut the light by half or more and don't always work with autofocus. They do have glass elements and must be protected.

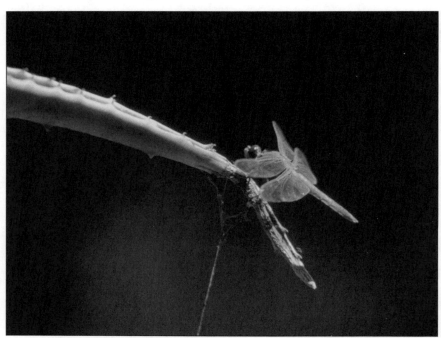

Easily seen and photographed with a telephoto, this perched dragonfly would be impossible to capture with short focal lengths. 200mm: 80-200mm zoom with close-focusing feature.

BELLOWS

A lens attachment that fits between the lens and camera body, allowing closer focusing of a lens. It is based on a folding, accordion-like center (the actual bellows).

Bellows are another close-up accessory, but are rarely seen with telephotos. A bellows fits between the lens and camera body like an extension tube, but its extension can be changed by the movement of a folding bellows. Bellows are somewhat fragile and are most often seen in the studio setting when extreme magnification is needed. Large telephotos typically are too heavy for the front part of a bellows.

Close-focusing Technique

Focusing on close-up subjects is a little different than standard focusing. At most distances, you simply focus manually or let the autofocus do its job until the subject is sharp. This creates a little problem up close. As the lens moves back and forth, toward and away from the film plane at normal distances, nothing changes except focus.

Close up, this movement also changes the magnification of the subject (which is affected by the distance of the lens from the film). When you start getting in really close to the subject, you may need to set the autofocus on manual, rough in your distance by focusing manually, then move the camera to and from the subject to hit focus, rather than focusing the lens (manually or automatically).

You can also set your autofocus on single shot, move in, lock focus on the subject at the desired magnification, then move the camera back and forth to fine focus (keeping the AF locked). Because the camera is moving while focusing, you must pause to settle the camera before squeezing off the shot — otherwise you'll consistently have camera movement problems. It also helps to use a faster shutter speed.

Close-up Depth of Field

Up close, depth of field becomes absolutely critical. Often, you're dealing with an area of focus in depth that can't even be measured in whole inches, even with the lens stopped down to smaller apertures.

With such limitations, you must choose carefully where your sharpness will be. This is another reason for not automatically using autofocus. You need to be sure that the sharpest point of the photograph is something you want to be

> "Up-close, depth of field becomes absolutely critical."

Autofocus can be a problem close-up. Either point the camera directly at the subject, lock focus, then reframe to the desired composition or just shoot manually. 85mm plus extension tube.

"Out-of-focus should never mean out-of-mind."

the sharpest. For example, if you're coming in close on a chipmunk, the critter won't look its best if the focus is on its ears or nose. For animals, the focus point looks best on the eyes.

Just because depth of field is narrow doesn't mean that the out-of-focus background is unimportant. Out-of-focus should never mean out-of-mind. Shapes, colors, and light and dark areas can either add to or detract from your subject. Always look at what's behind your subject, even if the background is out of focus.

Plane of Focus

Now suppose you want more than one spot in focus. You can stop the lens down to its smallest apertures, but this will severely limit your shutter speed options. You may have a real problem with subject or camera movement.

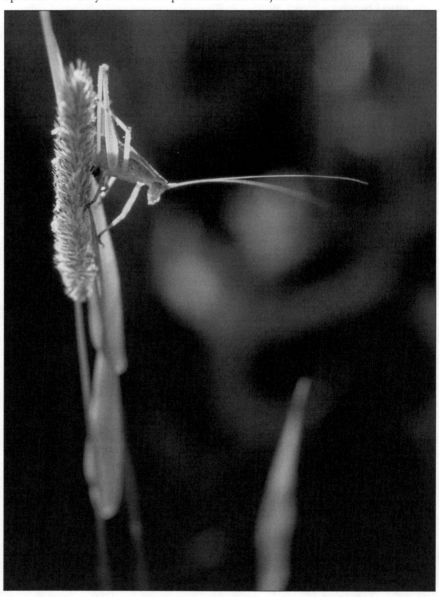

Since depth of field is very shallow when shooting up close with a telephoto, you must carefully select exactly what point you will focus on. 105mm plus extension tube.

By carefully adjusting the angle of your shot compared to the subject, you can get the most out of the limited depth of field of a close-up. 85mm with a close-up lens.

There is something you can do. Large-format camera owners know that if they contort the camera so that the film is parallel to the main plane of the subject, more of the subject will be in focus. Help for other cameras comes from understanding why this works. Your lens' area of focus is a plane parallel to the film plane (except for cameras with tilting lenses). The focus plane is thicker or thinner depending on how close you are (close is thin), the f-stop used (small f-stops makes it thick), and the focal length (telephotos make it thin).

As you tilt your whole camera, this plane also tilts. By tilting your camera so that the film plane (back of the camera) is parallel to your subject, you will include more of your subject in sharp focus because more of it is included in this plane of focus.

A perfect example of this is shooting a group of flowers. If you shoot at the first angle that seems appropriate, the plane of focus may only go through a

flower or two. If you start changing the angle of your camera to the flowers, you may find you can get more and more of them in focus, without changing an f-stop!

This also helps in controlling depth of field for less sharpness. Suppose you want the one flower with the butterfly to really stand out from nearby flowers? Tilt your camera so that it is at more of an angle to the flowers and not parallel. This will then swing the plane of focus away from the other flowers, making them more out of focus.

Selective Focus

Isolating a subject from its surroundings by having it sharp while everything else remains out-of-focus is called selective focus. This will define a composition so that a viewer is clearly drawn to the subject.

Telephotos do this so well that they might be called the close-up selective-focus lenses. The longer the focal length, the wider the lens opening, the closer the distance, the greater the effect. It is a very dramatic effect, too, with long lenses. They can turn foreground and background objects into wonderful blurs of color and tone swirling around the sharp subject.

"...wonderful blurs of color and tone..."

Telephotos help you "select out" your subject by limiting depth of field and turning the background into a blend of color and tone. 200mm plus extension tubes.

A person's eye wants to focus on something, so it will seek out the parts of the image that are sharp first. Selective focus limits this sharpness to the subject, and immediately draws the eye to the subject.

Using the plane-of-focus technique will help emphasize this by keeping your camera focused on the subject while tilting it 90° to the rest of the objects around the subject. This keeps that plane firmly on the subject, but nothing else. Still, you must pay attention to subtle details that can be overlooked. First, watch where your focus point is. Since the area of sharpness will be so strongly emphasized, be sure it is exactly where you want it to be.

Second, watch for distractions in the out-of-focus areas. A subtle composition of a gently-colored fern fiddlehead will be broken up by an out-of-focus red spot in the foreground. A nice shot of a dark beetle on a flower may be weakened by an overbright, out-of-focus highlight behind it.

Flowers

Flowers have such wonderful shapes and colors that it is easy to forget you are making a photograph. A flower simply centered in the viewfinder won't do — it's just a record shot. You need to look for ways to enhance the flower's

"...look for ways to enhance the flower's beauty..."

Patterns are one way to enhance a flower's beauty and change a snapshot into a photograph. By keeping the camera parallel to the plane of flowers, they all stay sharp, even with a wider f-stop. 85mm.

beauty, to show it off photographically. The telephoto is a good start, but you have to go away from only seeing the flower and begin thinking of that image in the viewfinder as a little photograph (or imagine it as a little TV screen). Ask yourself if you like the image (not the flower — you must already like the flower or you wouldn't be photographing it).

Looking for selective focus or using the plane of focus is a great place to start seeing any flower as part of a photograph. You can actually shoot through a colorful flower nearly touching the front of the lens. The telephoto won't "see" this flower, only the out-of-focus color, making for a striking effect.

Don't use the camera's viewfinder as a sighting device (sight the subject, push the shutter). Instead, use it as a painter uses a canvas — this is your image, so make it something that you like before you depress the shutter.

You can look for many things to enhance the subject. Light is basic. Be sure the light is flattering to the flower. Shadows either add dimension to a blossom or distract from its beauty, so always look for the shadows.

<table>
<tr><td></td></tr>
</table>

- *Front light* (light falling directly on the front of the subject) — is a flat light that emphasizes color and pattern.
- *Low front light* (early or late in the day) — can be very attractive and is especially good with telephotos. You cannot use a true low front light with wider focal length lenses because the shadow of the camera and lens will fall on the subject.
- *Side light* (light coming from the side) — is a highly dimensional light that really emphasizes the 3-D forms of flowers because it has both strong highlights and shadows. It also makes textures pop out. Extreme side light makes even the slightest texture gain depth.
- *Back light* (light from behind the subject) — is the most dramatic of lights and is often either a great success or a terrible failure. Its very high contrast can make an image chaotic, and it can cause flare problems in the lens. It also makes translucent flowers absolutely glow against dark shadows, creates sparkling highlights wherever there is water (especially dew), and separates the subject from its surroundings by giving it a rim or edge of light. It will give three or two dimensions (the lower the light, the less dimensional the image) and texture or no texture (again depending on the height of the light).

Finally, look at the out-of-focus flowers in the background and be sure you want their fuzzy colors and shapes in your photo.

Butterflies and Other Insects

Not everyone wants to deal with "bugs", yet they can make superb subjects for close-up explorations. An insect seen from afar may appear rather ugly, but up close can take on amazing forms and colors.

Butterflies are popular insect subjects, but trying to frame a flitting butterfly with a 50mm or wider lens is an exercise in frustration. Just as you get it in focus (if you can even get that close), it flies away in alarm.

Butterflies are best shot with moderate focal lengths — 200mm is great and 300-400mm can be very useful. A zoom with an extension tube works well because you can change focal lengths quickly to fit changing compositional needs, but remember that focus will also change.

DIFFERENT KINDS OF BASIC LIGHT:

- Front light
- Low front light
- Side light
- Back light

Other insects can be easily captured with short telephotos such as a 100mm macro or an 80mm with a close-up lens. They usually aren't as skittish as butterflies and the shorter focal lengths are easier to use for the very close distances needed with small insects.

Treat insect photography like wildlife photography. Move in slowly and deliberately, watching the insect for signs of nervousness. Watch your silhouette against the sky — that will spook most insects. Be careful you not to bump the plant where the insect rests. That will cause some insects to fly, others to drop to the ground.

Insects are most easily photographed early in the day, when it is cooler. They move sluggishly then. However, they can be harder to find because they aren't as active. The worst days are the hot, dog-days of summer — insects bounce around hurriedly like some animal hero in a kid's video game.

Other Close-up Subjects

So many, many subjects are transformed when you photograph them in close-up with a telephoto that it's hard to talk about all of them. No matter what you shoot, look for close-up opportunities in combination with your other shots. These details of life around us will add impact to any set of photographs you make.

"These details of life around us will add impact..."

Even the most common parts of your world are transformed when you see them in close-up. Such details of your world make for high-impact photos. 300mm macro.

Chapter 10

Tips on Telephoto Composition

Composition is a subject that always comes up with photographers because it so strongly affects how a photographer communicates with the viewers of his or her images. It controls what the viewer looks at, how the viewer perceives the subject, what relationships the viewer understands within the image area, and ultimately, the aesthetic appeal of the photograph.

Basic Composition

While traditional rules of composition can help you define your photograph better, they can also be very limiting if the photographer perceives composition as only a set of rules to follow. The results are photographs that largely look the same, don't always complement the strong points of the subject, and rarely communicate the photographer's unique impressions of the subject.

Keep the rules of composition in mind as suggestions rather than laws. Then fit the composition to the needs of the subject using the rules only as appropriate. To do this, ask yourself three simple questions:

1. What do I need to include in the image area?
2. What do I need to exclude from the image area?
3. What relationships do I need to have in my image area?

What to Include?

Even the rank beginner starts his or her composition by deciding what subject to include within the viewfinder, but subject choice is not the whole answer to this compositional question. How big should the subject be in the frame? How much of the subject is important? You're making a portrait of a little girl, so you choose a moderate telephoto that allows you to focus in on her face. If her dress is something that really defines her personality, consider using a short telephoto to include more of it in the image.

What belongs with the subject? How can you use your lens to include it? Sometimes it means moving your camera position slightly. It might mean using a longer focal length, because when you use a shorter focal length, you must get closer to the subject. Your angle to the subject then might be wrong to include important elements around it.

What do you include in the foreground or background? This often requires you to move the camera around the subject. Try going higher or lower, so that the foreground and background include different picture elements that complement or supplement your subject. With the change of perspective that a telephoto offers, you can also make foreground and background objects bigger or smaller in relationship to the subject.

"...fit the composition to the needs of the subject..."

What to Exclude?

What doesn't belong with the subject and how can you keep it out of the picture? How many times have photographers had a wonderful image in mind when the shutter was snapped, only to be greatly disappointed when they get it back from the processor? Somebody's foot shows up in a corner, or a telephone pole rises in a pristine landscape. Just as important as "what to include" is what you keep out of the photo.

One problem many amateurs have is that they see the subject better than the camera does. The subject becomes magnified in their mind, even though it is still small in the viewfinder. This often results in the wrong things being included in the foreground or background. A lot of extras get included in the picture because the "magnified" subject overpowers them in the viewfinder.

A telephoto gives you the chance to frame in on what's really important to the subject, and frame out everything else. Watch the edges of the viewfinder. Search for things that don't belong there, things inappropriate to the subject or even distracting to the composition.

You also have to look for things that don't belong in foregrounds and backgrounds. The ability of the telephoto to make foregrounds and/or backgrounds out-of-focus can be a great benefit in keeping things out of a photograph. What needs to be sharp? What needs to be unsharp? An unsharp object can be a creative element that sets off the subject. If that object were sharp, it might be terribly distracting. The perspective effect will also help to exclude unwanted elements in a background. Use a longer lens and back up to make the background bigger compared to the subject, and you'll often be able to simplify what's behind the subject.

"...you'll often be able to simplify what's behind the subject."

What relationships do you need?

Once you've decided what's in and what's out, you have to decide where things need to go within the picture area. There are many relationships within a photograph, including subject-to-edge, subject-to-space around it, subject-to-foreground, subject-to-background, foreground-to-background, subject/foreground/background-to-horizon, subject to a color/shape/form, subject to related objects (e.g., a flower to other flowers), subject to unrelated objects (e.g., a building to a grove of trees), subject-to-movement (if something's moving or implied to be moving), and on and on.

Because these relationships can get rather complex, many photographers retreat to the rules here. That will work, but it won't make for the dramatic, personal photography that really expresses your reaction to the world.

The best way to learn to see relationships is to study the viewfinder. This is where a tripod can be extremely helpful so that the framing doesn't change while you're looking. Check how the subject looks in relation to everything else in the frame. What do the edges of the frame look like? Are most things at the bottom, top, right, left, corners? Where?

Shoot some of those images. Pictures often look different when they're in your hand, away from the subject. You can then see how successful the image is (how good the photo looks) with the relationships you found. You'll like some photos, hate others, but you can learn from them all. Bracket your compositions. Don't be satisfied with the first composition you find. Take that shot, then look for more. Try bracketing perspective, too, by changing the focal length and adjusting your position to the subject as you shoot.

Height and angle

How high or low you are to a subject greatly influences the compositional elements of the resulting photograph. This is a major, major difference between wide-angle and telephoto lenses.

When you use a wide-angle lens and get close to a large subject, you often need to look up to keep it in frame. This makes backgrounds get smaller and lower. The same framing with a telephoto requires you to back up, resulting in more level look at the subject. Backgrounds then become larger and higher in the frame.

With a wide-angle lens, you have to move big distances (right or left, up or down) to find a significant difference in the relationship of subject to background. With a telephoto, moving just a little changes the background instantly because of the narrow angle of view.

As you move into or away from a subject with a wide-angle lens, the perspective effects and the angle of view will change quite rapidly and dramatically. Since you are always at a distance from your subject with a telephoto, your angle to it changes more slowly as you move forward or back.

Still, height to the subject does make a difference with both telephotos and wide-angles. As you get lower with a wide-angle, the foreground becomes even more prominent and creates extreme perspective effects. With a telephoto, as you drop your height, foreground elements begin appearing, but they are often out-of-focus abstract shapes, or if sharp, more in scale with the actual size of the subject.

Composition is basically deciding what belongs in the photo, what needs to be kept out and how the picture elements relate to each other and the edges of the frame. 200mm.

...moving just a little changes the background instantly..."

Chapter 11

QUESTIONS AND ANSWERS

Can I use a spotting scope as a telephoto lens? How would it compare to a regular telephoto?

Spotting scopes offer a lot of magnification (20x power and more) in a compact package ideal for bird watching, whale spotting and wildlife searching. There are adapters that allow you to use them on a camera as a lens.

The good news is that they give that magnification for the camera, too. The bad news is that, compared to even an inexpensive telephoto lens and tele-converter, most aren't very sharp, offer poor contrast, and aren't very bright (have small lens openings). They work in a pinch, but can rarely be considered a good substitute for a lens designed to be used as a telephoto. The only exception is a scope with apochromatic correction or low-dispersion glass. These can be sharp and contrasty, but still have small f-stops.

Suppose I want even more magnification from my lenses. Can I stack teleconverters?

Teleconverters can indeed be stacked, but realize that quality and light levels drop with each additional extender. With good lenses and good multi-element extenders, this can work for special effects, such as huge suns or abstract images of distant scenes. With such images, the effect is what's important, so a photo with less than optimum sharpness won't be noticed.

When shooting with my telephoto toward the sun to get some back light on the subject, I sometimes get a pinkish, circular area in the corner of the picture away from the sun. What is it?

This is probably your skylight filter reflecting back into the lens. Telephotos have rather flat front elements compared to wide-angles. Since you're shooting into the sun, the sun light will hit the front of your lens and bounce off (even with modern multi-coated lenses). If a skylight filter is there, light then bounces off of it and back into the lens, picking up some of the color of the filter. It now becomes lens flare and is recorded on film as that circular, pinkish area. To avoid this, use a filter only when you really need one. Use a lens hood to minimize the possibilities of the sun hitting the front of your lens, too. The lens hood will also protect your lens from damage.

Are used telephotos okay?

They can be great — you can often find some real bargains in excellent telephotos that only have manual focus capability. The market is such today that

> ### SPOTTING SCOPE
>
> A powerful telescope used by bird watchers, hunters and other outdoor people. Usually 20x power and more.

manual-focus lenses have no market. People want autofocus, so the prices for used manual-focus lenses have dropped to very low levels. This is an excellent way to pick up a very long lens that might be way too expensive in autofocus. Just examine the lens carefully for any damage — reject any with obvious dents on the outside, chips in the lenses, or pronounced rattle in the lens barrel. Also, be sure it stops down correctly on your camera body and that the apertures don't stick.

Avoid old zoom telephotos. They just are not as sharp as modern telephotos (including zooms).

Are zooms really good enough for serious photography?

Today's zooms provide excellent sharpness, and they are used by professionals throughout the world. Most people would be hard pressed to tell a shot made by a zoom versus one made by a similar-priced single-focal length lens.

I understand that lens shades are important. Are rubber ones better than metal or plastic for protecting the lens?

No. Rigid lens shades actually provide more protection because they are strong enough to keep branches and such away from the front of the lens (rubber lens shades aren't). They also flex enough to absorb some impact, yet retain stiffness to keep the impact from the lens surface. Rubber lens shades deform too easily from pressure and can sneak into the edge of a shot. Also, rubber lens shades are rarely made to precisely mask out extraneous light the way a matched hard shade is.

Long telephotos are often rather front-heavy. What can I do to handle them better?

The first thing to consider is how to support the lens. When handholding the camera, keep your elbows in, left hand palm up, and the lens resting on the palm. Never hold the camera and lens only by the camera. If your lens has a tripod mount, use it whenever you attach the camera to the tripod, monopod or shoulder mount. If it doesn't have a tripod mount, look into accessory mounts that are available from specialty manufacturers like Bogen or Kirk Enterprises of Angola, Indiana. You can also use a bean bag to support the lens on any support that will hold the bag.

I'm just getting started in photography and find that the telephotos I want are too expensive. What can I do?

There are several options to consider. First, look into used lenses as described above. Second, look for slower-speed lenses. The faster the lens (the wider the maximum f-stop), the more expensive the lens, but this does not mean the lens is better in optical quality. A fast lens requires more elements inside and bigger pieces of optical glass that get expensive to make. Same manufacturer 300mm f/4 and f/2.8 lenses with the same type of correction (e.g., both APO) will give results that will likely be impossible to tell apart, yet the f/2.8 lens can be three times the cost of the f/4 lens. The difference is that extra f/stop of light. Make up for it by using a faster film if you can. Third, look for slower-speed, shorter range telephotos. An 80-200mm f/4.5-5.5 lens is less expensive than an 80-200 f/2.8 or a 28-200mm lens. Fourth, use a quality, multi-element teleconverter to increase the focal length of the lenses you do have. You can also find matched extenders that work well to make a moderately-

priced 300mm lens into the equivalent of a very expensive 420 or 600mm lens (it will be slower, of course).

Why do telephoto landscape or travel shots often look "grayer" and less contrasty than wide-angle shots?

The main reason is the amount of air a lens has to shoot through before the subject can be captured. With a wide-angle lens, a small amount of air rests between you and the closest part of your image. With a telephoto, you will be farther away from the subject. Quite a lot of air may be in between you and the subject. If anything is in that air, humidity, fog, smog, dust, heat shimmer, the telephoto will compress and magnify it so that the image loses contrast.

I want to shoot some close-ups with a telephoto perspective, but of course my depth of field is limited. Are there any special lenses that will give me a little more sharpness?

A special lens, called a tilt lens, can increase the sharpness in depth without stopping the lens down more or using a wider focal length. Canon makes a moderate telephoto 90mm tilt lens that actually "bends" — it tilts toward the subject. This changes the plane of focus (see Chapter 9, page 86) so that it is no longer parallel to the film plane. Instead, the plane of focus is parallel to the front of the lens. As you tilt the lens toward the subject, this plane of focus picks up more and more parts of the subject in sharpness. This only works on flattish subjects that extend into the distance. Tall objects will lose sharpness at top and bottom as the plane of focus tilts off of them.

TILT LENS

A lens that "bends" or tilts toward or away from the subject so sharpness in depth is increased or decreased. Usually the lens also shifts side-to-side, and up-and-down as well for perspective correction.

Chapter 12

PARTING THOUGHTS

Telephoto and wide-angle focal lengths are important creative tools for every serious photographer. Though this book has given a lot of ideas for capitalizing on the strengths of telephotos, wide-angles have their strengths, too.

Photography is a wonderful way to explore the world. While it seemingly captures reality, it actually is a tremendous creative medium that allows you many choices in how to interpret the world. "Photographs never lie" has never been true. If it were, photography would be simply a boring, uncreative way of recording the world.

Photographs always lie in the sense that they always reproduce the photographer's point-of-view (intended or not). The choice and framing of the subject alone isolates the subject from reality (the viewer cannot know what was outside of the frame, what action occurred before or after the shot, what the smells and sounds were, and a whole lot of other things).

Change focal length and the world changes, too. Shoot a field of flowers with a wide-angle lens and the perspective opens up, making the flowers seem far apart. Suppose the photographer then argued that these flowers were very sparse and needed help.

Then another photographer shoots the same field with a long telephoto, using the compression of perspective that such a lens offers. Now the flowers are jammed together in profuse color. Suppose this photographer said the flowers were too abundant and needed to be harvested.

Who was right? Both and neither. Photography can only interpret the world. How the photographer uses the tool of focal length is up to him or her. When people learn the power of a photograph to adjust the perception of reality, all photographs are easier to understand and interpret.

Telephotos are a lot of fun. Good luck as you explore their possibilities.

"Good luck as you explore their possibilities."

Left: *A small church in the distance is just a speck with short focal lengths. A very long lens reaches out to magnify and isolate the subject for the photograph. 480mm: 300mm plus 1.6x teleconverter.*

Below: *Use a long lens to isolate and abstract interesting details in the distance. The relationships of dark trees and tombstones disappear as you get close with wider angle lenses. 300mm.*

Get up close and personal with wildlife by using a telephoto and thinking about your approach. Use the ability of the lens to isolate important parts of picture so it effectively communicates what you want it to communicate. The telephoto also allows you to keep out unimportant or distracting elements by letting you zero in on what is really important about your image. Both photos were taken with a focal length of 300mm.

A light spring rain gains a light fog look through the use of a telephoto. Long lenses concentrate any atmospheric effects. 200mm.

APPENDIX

Camera and Lens Manufacturers

Canon U.S.A., Inc. — *Canon cameras and lenses*
One Canon Plaza
Lake Success, NY 11042
516/488-6700

Hasselblad USA — *Hasselblad cameras and lenses*
10 Madison Rd.
Fairfield, NJ 7004
201/227-7320

Kyocera Electronics Inc.— *Yashica and Contax*
cameras and lenses
100 Randolph Rd.
Somerset, NJ 08875-6802
908/560-0060

Leica Camera, Inc. — *Leica cameras and lenses*
156 Ludlow Ave.
Northvale, NJ 07647
201 767 7500
800/222-0118

Mamiya America Corp. — *Mamiya cameras and lenses*
8 Westchester Plaza
Elmsford, NY 10523
914/347-3300

Minolta Corporation — *Minolta cameras and lenses*
101 Williams Dr.
Ramsey, NJ 07446
201/825 4000

Nikon USA — *Nikon cameras and lenses*
1300 Walt Whitman Rd.
Melville, NY 11747
516/547-4200

Olympus America Inc. — *Olympus cameras and lenses*
145 Crossways Park West
Woodbury, NY 11797
516 844 5000

Pentax Corporation — *Pentax cameras and lenses*
35 Inverness Drive E.
Englewood, CO 80112
303 799 8000

Ricoh Corp. — *Ricoh cameras and lenses*
475 Lillard Dr.
Sparks, NV 89434
702/352-1610

Sigma Corp. of America — *Sigma lenses for SLR's and Sigma cameras*
15 Fleetwood Court
Ronkonkoma, NY 11779
516/585-1144

Tamron Industries — *Tamron lenses for SLR's*
125 Schmitt Blvd.
Farmingdale, NY 11735
516/694-8700

THK Photo Products, Inc. — *Tokina lenses for SLR's*
1512 Kona Dr.
Compton, CA 90220
310/537-9380

Vivitar Corp. — *Vivitar lenses for SLR's*
1280 Rancho Conejo Blvd.
Newbury Park, CA 91320
805/498-7008

Accessories Manufacturers

Bogen Photo Marketing — *Bogen and Gitzo tripods/heads*
565 E. Crescent Ave.
Ramsey, NJ 07446-0506
201/818-9500

Calumet Photographic — *Tripods and heads, filters*
890 Supreme Dr.
Bensenville, IL 60106
708/860-7447

Lee Filters — *Filters*
2301 W. Victory Blvd.
Burbank, CA 91506
818/238-1220

Minolta — *Cokin filters*
101 Williams Dr.
Ramsey, NJ 07446
201/825-4000

Slik America, Inc. (Division of Tocad America) — *Slik Tripods*
300 Webrox Rd.
Parsippany, NJ 07054
201/428-9800

THK Photo Products — *Hoya filters*
1512 Kona Dr.
Compton, CA 90220
310/537-9380

Tiffen — *Davis and Sanborn tripods, filters*
90 Oser Ave.
Hauppaugue, NY 11788
516/273-2500

Zone VI — *Zone VI wooden tripods*
Newfane, VT 5345
802/257-5161

GLOSSARY

achromatic lens — most modern lenses are designed to minimize problems with colors focusing at different points through achromatic designs, which highly correct chromatic aberration for two wavelengths.

aerial perspective — the effect seen as any object goes farther into the distance: the object gets lighter, bluer and has less contrast. This occurs because of dust, humidity, and other things in the air.

angle of view — the angle that a lens sees using the lens as the apex or point of the angle.

aperture — the opening in a lens through which the light (and image) travel (also called the f-stop). It is changed to adjust the amount of light coming through to the film. This also affects depth of field (a smaller lens opening gives more depth of field). The numbers can be confusing (they actually represent fractions) since a small f-stop number (such as f/2.8) is a wide aperture, and a large number (such as f/16) is a small aperture.

apochromatic lens — a lens designed for highly correcting chromatic aberration for three wavelengths of light. Telephoto lenses have more trouble than standard focal lengths in focusing all colors to a single point, resulting in chromatic aberration. Apochromatic designs are designed to greatly reduce chromatic aberration.

aspheric lens — a special lens element having a free-curving surface (not spherical) that corrects spherical aberration in a lens (mostly a problem with very large aperture and wide-angle lenses).

back light — light that hits the part of your subject away from you, so the light actually comes toward the camera

bellows — a lens attachment that fits between the lens and camera body, allowing closer focusing of a lens. It is based on a folding, accordion-like center (the actual bellows).

blind — a covering of photographer and camera that conceals the shape and movement of the photographer. Commonly a tent-like structure.

bracketing — changing settings of the camera for the same image so you get some variation in the final shot. Most commonly used with exposure.

bracketing composition — changing the composition of the same subject so you can try out some different approaches to the same image.

bracketing perspective — changing lenses and distance to the subject so the relative distances between foreground, subject and background change in a series of photos.

cable release — a cable that attaches to the shutter of a camera so a tripod-mounted camera can be set off without physically touching the camera (which can cause vibration and unsharpness at slow shutter speeds). They come in mechanical and electronic versions.

chromatic aberrations — as glass refracts light, it will also pull apart colors (as in a rainbow), which results in chromatic aberrations, a lens defect. Modern lenses are designed with multiple lens elements to bring colors back together.

comatic aberration — this defect causes a pinpoint of light coming from the edges of a lens to distort into a comet shape. It also causes flare in out-of-focus areas.

depth control — affecting the depth or change of subject/background relationships in a photo. One potent tool for doing this is changing focal lengths of lenses.

depth-of-field — the distance of sharpness in a photo from front to back. Depth-of-field is a continuum from sharp to out-of-focus and is affected by aperture (large aperture is less, small is more), distance to subject (close is less, far is more) and lens choice (wide-angle is more, telephoto is less).

extension tube — a simple tube with no lens elements that fits between the camera body and lens to allow the lens to focus closer.

f-stop — the maximum or widest aperture of a lens or the aperture used for the exposure. An f/2.8 lens, for example, is a lens with a maximum aperture of f/2.8. That lens can then be set to 1/125 at f/11 for an f-stop of f/11 for the exposure used.

filters — optical elements that are added to the front of the lens that change some aspect of the photograph. Vary from polarizing filters to graduated filters to colored filters for black-and-white.

focal length — the distance from the optical center of a lens to the film plane of the camera. Smaller numbers mean shorter focal lengths, wider angles of view. Larger numbers are longer lenses with narrower angles of view.

front light — light that hits the front of your subject as the subject faces you, so the light actually comes from behind you.

internal baffling — special baffles built into the light path reduce the amount of excess light bouncing around inside the lens (this cuts flare).

internal focus — groups of lens elements inside the lens move to focus, rather than moving the whole lens away from the film plane (common to older lenses). This internal focusing keeps the lens shorter, maintains the balance of the camera and allows closer focusing.

lens aberrations — defects in the performance of a lens due to optical problems.

lens elements — camera lenses are made of many lens elements that correct for optical defects of single lenses.

lens flare — bright light bouncing around inside a lens causes flare. Flare degrades the image by reducing contrast (diffuse flare) or by adding spots of "light" to the image (specular flare). It can be reduced by using a lens hood or shade.

lens shade — also called a lens hood. This metal or plastic tubular attachment screws into the front of a lens and protects it from bright light that might cause lens flare. It also keeps fingers off the lens and shields it from the weather.

long lens — this simply refers to any lens with a focal length longer than the "normal" 50mm for 35mm cameras. Modern "long" lenses can be fairly short because of telephoto designs.

macro lens — a lens specially corrected for optimum performance at close-focusing distances.

macro photography — a term loosely used to cover the closer work of close-up photography. Often, it will be defined more precisely down to levels where there is some magnification of the subject.

monochromatic aberrations — aberrations of lenses not due to color — this includes spherical and comatic aberrations.

monopod — a highly portable form of camera support that is like one leg of a tripod. Very portable and light, it is ideal for wildlife and sports photography.

perspective — how picture elements change in size with distance. Close objects look bigger than distant objects, but the exact size relationship can be changed by changing focal lengths.

plane of focus — when focusing on a scene, the actual point of focus is a plane parallel to the back of the camera.

protective filters — under extreme conditions, such as blowing sand, a UV or skylight filter can be used to protect the front of the lens. Otherwise, a lens shade is better and will never degrade the performance of the lens (which a cheap filter can do).

reciprocity failure — under extremely long (over 1 sec.) or short exposures (less than 1/10,000), film changes its response to exposure, losing some of its sensitivity and requiring you to increase exposure. This can also change color response of a film.

selective focus — by limiting sharpness to a small area, a subject can be "selected" by the focus of the lens, making it stand out. This is done by shooting with longer lenses and wider apertures.

shoulder mount — also called a gunstock mount. Camera support highly suited to telephoto lenses that uses the photographer's shoulder for added stability while shooting.

shutter speed — the time the shutter is actually open during the exposure. The numbers, such as 125, 250, 500, etc., represent fractions of a second, 1/125, 1/250, 1/500. Each halving or doubling of a number is equivalent to a full f-stop.

side light — light that hits the side of your subject, which also means it hits the side of you as well

single-lens reflex (SLR) — a camera that uses the same lens for the viewfinder as for the actual photograph. A mirror reflects light to the viewfinder while composing, then flips out of the way to allow the image to reach the film during the exposure.

skylight filter — a slightly warm filter that will slightly warm a scene. It has little value when you use print films except as a protective filter under adverse conditions.

spherical aberration — this optical problem occurs because light passes through a lens differently along the thinner edges than in the thicker middle. This is hardest to correct for in wide-aperture lenses and wide-angle lenses.

spotting scope — a powerful telescope used by bird watchers, hunters and other outdoor people. Usually 20x power and more.

teleconverter — also called converters, extenders or tele-extenders. This is a lens attachment that fits between the lens and the camera body that magnifies the image from the lens by a factor of approximately 1.5x or 2x. The teleconverter reduces the amount of light from the lens and also magnifies lens defects, so a high-quality lens and teleconverter are key.

telephoto lens — a long lens that has a special optical design to reduce its physical size. An unmodified 500mm lens, for example, would be 500mm long (approximately 20 inches). The same focal length in a telephoto design could be half of that. Most modern lenses longer than the normal 50mm are telephoto designs.

tilt lens — a lens that "bends" or tilts toward or away from the subject so sharpness in depth is increased or decreased. Usually the lens also shifts side-to-side, and up-and-down as well for perspective correction.

tripod — a very important camera support that uses three collapsible legs to form a base for camera and lens. A key piece of equipment for critical use of telephoto lenses.

TTL meter — a metering system that actually measures the light coming through the lens (TTL) to the film to gain the right exposure.

vignetting — cutting into the corners and edges of the image area so it darkens. This commonly occurs when using the wrong size filter or lens hood, but is sometimes also seen at the widest settings of extreme-range zooms when shot wide-open (maximum aperture).

wavelengths — light is made up of "waves" and the frequency of those waves, or wavelengths, produces the colors we see.

wide-angle lens — a lens that has a smaller focal length than 50mm (in 35mm equipment), which results in a wider angle of view on the scene. Also called a short lens.

zoom lens — a lens with multiple focal lengths built into one unit. You zoom from wider to narrower angles of view, or from shorter to longer focal lengths.

INDEX

Other Books from Amherst Media, Inc.

Basic 35mm Photo Guide
Craig Alesse

Great for beginning photographers! Designed to teach 35mm basics step-by-step — completely illustrated. Features the latest cameras. Includes: 35mm automatic and semi-automatic cameras, camera handling, f-stops, shutter speeds, and more! $12.95 list, 9 x 8, 112 p, 178 photos, order no. 1051.

Infrared Photography Handbook
Laurie White

Totally covers black and white infrared photography: focus, lenses, film loading, film speed rating, heat sensitivity, batch testing, paper stocks, and filters. Black & white photos illustrate how IR film reacts in portrait, landscape, and architectural photography. $24.95 list, 8 1/2 x 11, 104 p, 50 B&W photos, charts & diagrams, order no. 1419.

Wedding Photographer's Handbook
Robert and Sheila Hurth

The best and most up-to-date book about wedding photography! The complete step-by-step guide to photographing weddings – everything you need to start and succeed in the exciting and profitable world of wedding photography. Packed with shooting tips, equipment lists, must-get photo lists, business strategies, and much more! $24.95 list, 8 1/2 x 11, 176 p, index, b&w and color photos, diagrams, order no. 1485.

Glamour Nude Photography
Robert and Sheila Hurth

Create stunning nude images! Robert and Sheila Hurth guide you through selecting a subject, choosing locations, lighting, and shooting techniques. Includes information on posing, equipment, makeup and hair styles, and more! $24.95 list, 8 1/2 x 11, 144 p, over 100 b&w and color photos, index, order no. 1499.

Lighting for People Photography
Stephen Crain

The complete guide to lighting and its different qualities. Includes: set-ups, equipment information, how to control strobe and natural lighting, and much more! Features diagrams, illustrations, and exercises for practicing the lighting techniques discussed in each chapter. $24.95 list, 8 1/2 x 11, 112 p, b&w and color photos, glossary, index, order no. 1296.

Wide-Angle Lens Photography
Joseph Paduano

For everyone with a wide-angle lens or people who want one! Includes taking exciting travel photos, creating wild special effects, using distortion for powerful images, and much more! Part of the Amherst Media's Photo-Imaging Series. $15.95 list, 7 x 10, 112 p, glossary, index, appendices, b&w and color photos, order no. 1480.

Zoom Lens Photography
Raymond Bial

Get to know the most versatile lens in the world! Includes how to take vacation, landscape, still life, sports and other photos. Features product information, accessories, shooting tips, and more! Part of the Amherst Media's Photo-Imaging Series. $15.95 list, 7 x 10, 112 p, b&w and color photos, index, glossary, appendices, order no. 1493.

Big Bucks Selling Your Photography
Cliff Hollenbeck

A complete photo business package for all photographers. Includes secrets to making big bucks, starting up, getting paid the right price, and creating successful portfolios! Features setting financial, marketing and creative goals. This book will help to organize business planning, bookkeeping, and taxes. $15.95 list, 6x9, 336 p, Hollenbeck, order no. 1177.

Camera Maintenance & Repair
Thomas Tomosy

A step-by-step, fully illustrated guide by a master camera repair technician. Sections include: testing camera functions, general maintenance, basic tools needed and where to get them, basic repairs for accessories, camera electronics, plus "quick tips" for maintenance and more! $24.95 list, 8 1/2 x 11, 176 p, order no. 1158.

Camera Maintenance & Repair Book 2: Advanced Techniques
Thomas Tomosy

Building on the basics covered in the first book, this book will teach you advanced troubleshooting and repair techniques. It's easy to read and packed with photos. An excellent reference and companion book to *Camera Maintenance & Repair*! $29.95 list, 8 1/2 x 11, 176 p, order no. 1558.

Great Travel Photography
Cliff and Nancy Hollenbeck

Learn how to capture great travel photos from the Travel Photographer of the Year! Includes helpful travel and safety tips, packing and equipment checklists, and much more! Packed full of photo examples for all over the world! Part of the Amherst Media's Photo-Imaging Series. $15.95 list, 7 x 10, 112 p, b&w and color photos, index, glossary, appendices, order no. 1494.

Infrared Nude Photography
Joseph Paduano

A stunning collection of natural images with wonderful how-to text. Over 50 infrared photos. Shot on location in the natural settings of the Grand Canyon, Bryce Canyon and the New Jersey Shore. $19.95 list, 9 x 9, 80 p, over 50 photos, order no. 1080.

McBroom's Camera Bluebook
Mike McBroom

Comprehensive, fully illustrated, with price information on: 35mm cameras, medium & large format cameras, exposure meters, strobes and accessories. Pricing info based on equipment condition. A must for any camera buyer, dealer, or collector! $29.95 list, 8x11, 224 p, 75+ photos, order no. 1263.

Build Your Own Home Darkroom
Lista Duren & Will McDonald

This classic book shows how to build a high quality, inexpensive darkroom in your basement, spare room, or almost anywhere. Information on: darkroom design, woodworking, tools, and more! $17.95 list, 8 1/2 x 11, 160 p, order no. 1092.

Into Your Darkroom Step-by-Step
Dennis P. Curtin

The ideal beginning darkroom guide. Easy to follow and fully illustrated each step of the way. Information on: equipment you'll need, set-up, making proof sheets and much more! $17.95 list, 8 1/2 x 11, 90 p, hundreds of photos, order no. 1093.

The Freelance Photographer's Handbook
Fredrik D. Bodin

A complete handbook for the working freelancer. Full of how-to info & examples. Includes: marketing, customer relations, inventory systems, portfolios, and much more! $19.95 list, 8 x 11, 160 p, order no. 1075.

Handcoloring Photographs Step by Step
Sandra Laird & Carey Chambers

The new standard reference for handcoloring! Learn step by step how to use a wide variety of coloring media, such as oils, watercolors, pencils, dyes and tones, to handcolor black and white photos. Over 80 color photos illustrate how-to handcoloring techniques! $29.95 list, 8 1/2 x 11, 112 p, color and b&w photos, order no. 1543.

The Wildlife Photographer's Field Manual
Joe McDonald

The complete reference for every wildlife photographer. A practical, comprehensive, easy-to-read guide with useful information, including: the right equipment and accessories, field shooting, lighting, focusing techniques, and more! Features special sections on insects, reptiles, birds, mammals and more! $14.95 list, 6 x 9, 200 p, order no. 1005.

Camcorder Business
Mick and George A. Gyure

Make money with your camcorder! This book covers everything you need to start a successful business using your camcorder. Includes: editing, mixing sound, dubbing, technical and business tips, and much more! Also features information on covering a wedding or other special event for a client, legal and industrial videos, and more. $17.95 list, 7 x 10, 256 p, order no. 1496.

More Photo Books Are Available

Write or fax for a _FREE_ catalog:
Amherst Media, Inc.
PO Box 586
Buffalo, NY 14226 USA

Fax: 716-874-4508

Amherst Media's Customer Registration Form

Please fill out this sheet and send or fax to receive free information about future publications from Amherst Media.

CUSTOMER INFORMATION

DATE

NAME

STREET OR BOX #

CITY STATE

ZIP CODE

PHONE () FAX ()

OPTIONAL INFORMATION

I BOUGHT *TELEPHOTO LENS PHOTOGRAPHY* **BECAUSE**

I FOUND THESE CHAPTERS TO BE MOST USEFUL

I PURCHASED THE BOOK FROM

CITY STATE

I WOULD LIKE TO SEE MORE BOOKS ABOUT

I PURCHASE BOOKS PER YEAR

ADDITIONAL COMMENTS

FAX to: 1-800-622-3298

CUT ALONG DOTTED LINE

①

②

Name_____

Address_____

City_____State_____

Zip_____ — _____

Place
Postage
Here

Amherst Media, Inc.
PO Box 586
Buffalo, NY 14226

③